ANIMAL STUDIES

550 Illustrations of Mammals, Birds, Fish and Insects

M. MÉHEUT

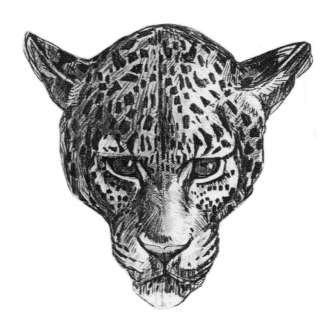

DOVER PUBLICATIONS, INC.
Mineola, New York

CONTENTS

Published in Canada by General Publishing Company, Ltd., 30 Lesmill Road, Don Mills, Toronto, Ontario.

Published in the United Kingdom by Constable and Company, Ltd., 3 The Lanchesters, 162–164 Fulham Palace Road, London W6 9ER.

Bibliographical Note

This Dover edition, first published in 1999, is a republication of all 100 plates from the work originally published in two volumes by Librairie Centrale des Beaux-Arts, Paris, in 1911 under the title *Études d'animaux*. The plates have been rearranged alphabetically according to the newly added English captions and an Index has been specially prepared for this edition.

DOVER *Pictorial Archive* SERIES

Library of Congress Cataloging-in-Publication Data

Méheut, Mathurin, 1882–1958.
 [Etudes d'animaux. English]
 Animal studies : 550 illustrations of mammals, birds, fish and insects / M. Méheut.
 p. cm. — (Dover pictorial archive series)
 Includes index.
 ISBN 0-486-40266-5 (pbk.)
 1. Decoration and ornament—Animal forms. I. Title. II. Series.
NK1555.M4513 1999
760'.04432—dc21
 98-44101
 CIP

Manufactured in the United States of America
Dover Publications, Inc., 31 East 2nd Street, Mineola, N.Y. 11501

.CHAUVE-SOURIS.

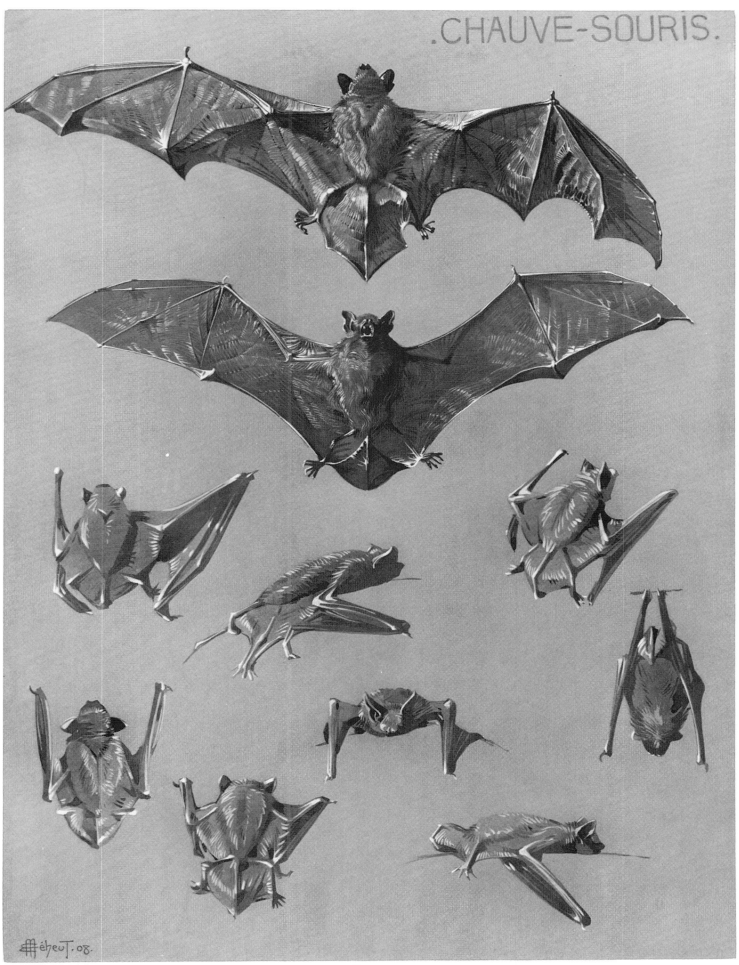

Bat

Plate 2 *Mammals*

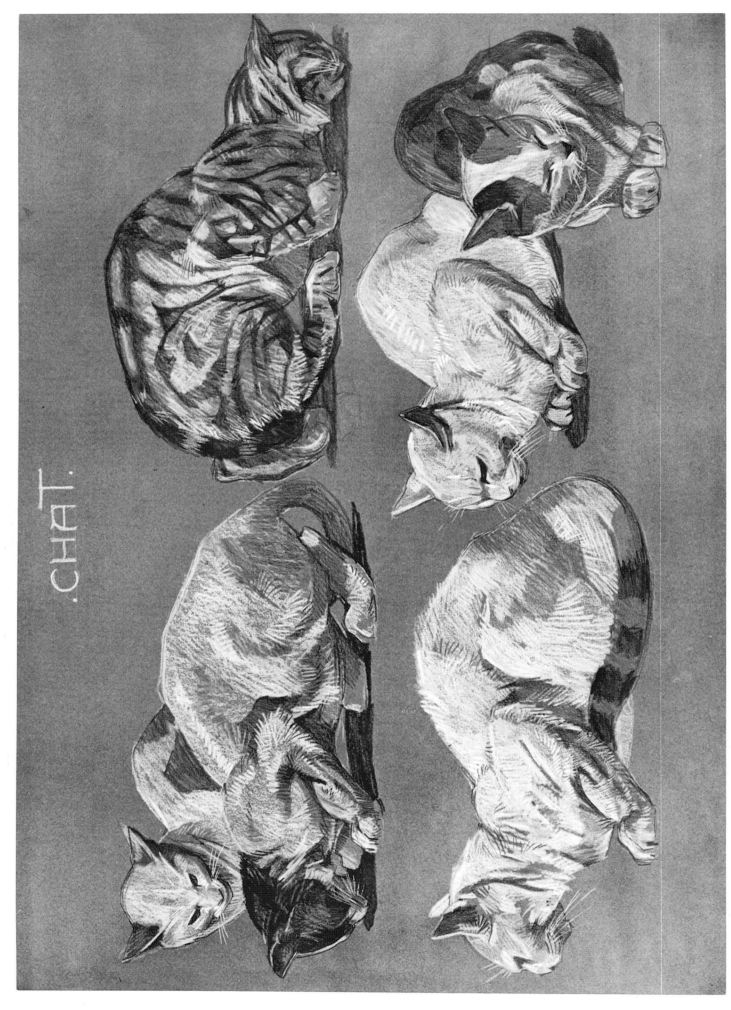

CHAT.

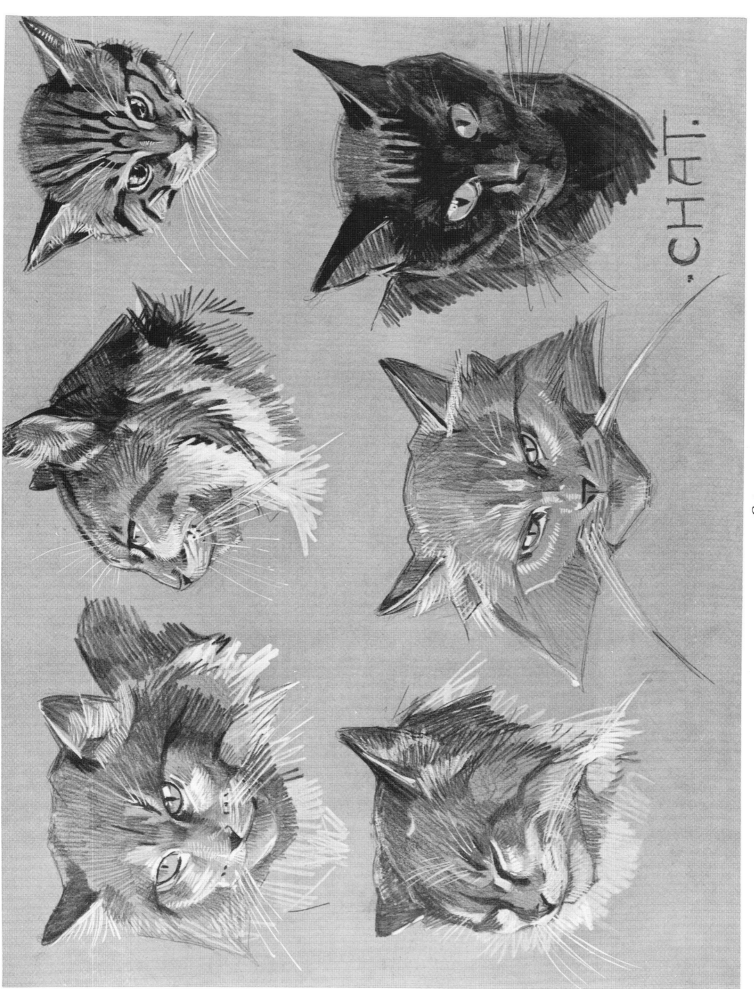

.CHAT.

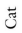

Cat

Plate 4 *Mammals*

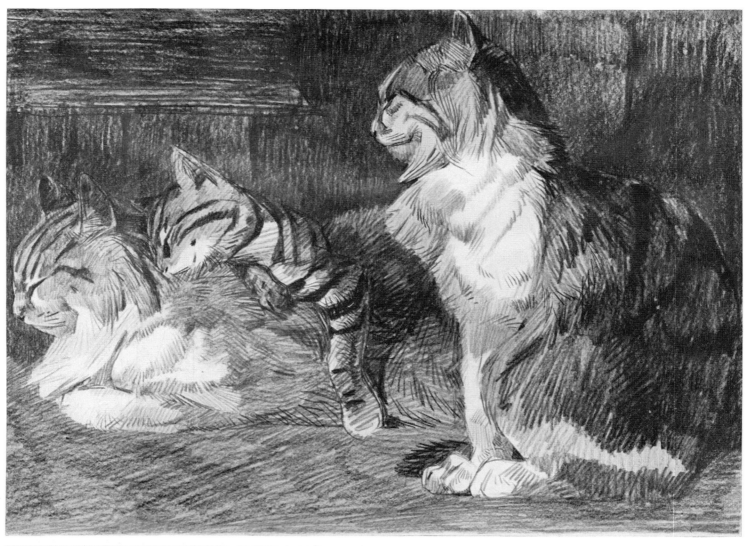

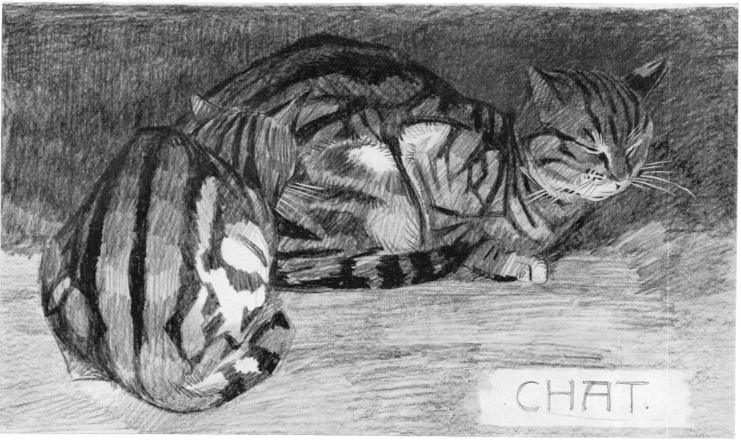

Cat

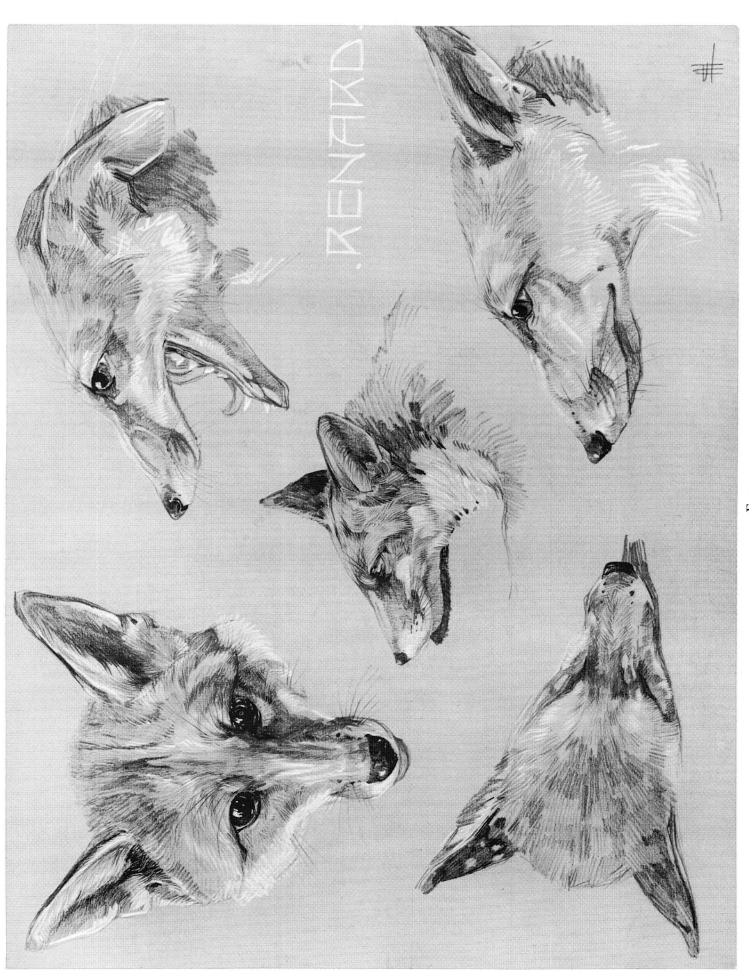

Fox

Plate 6 *Mammals*

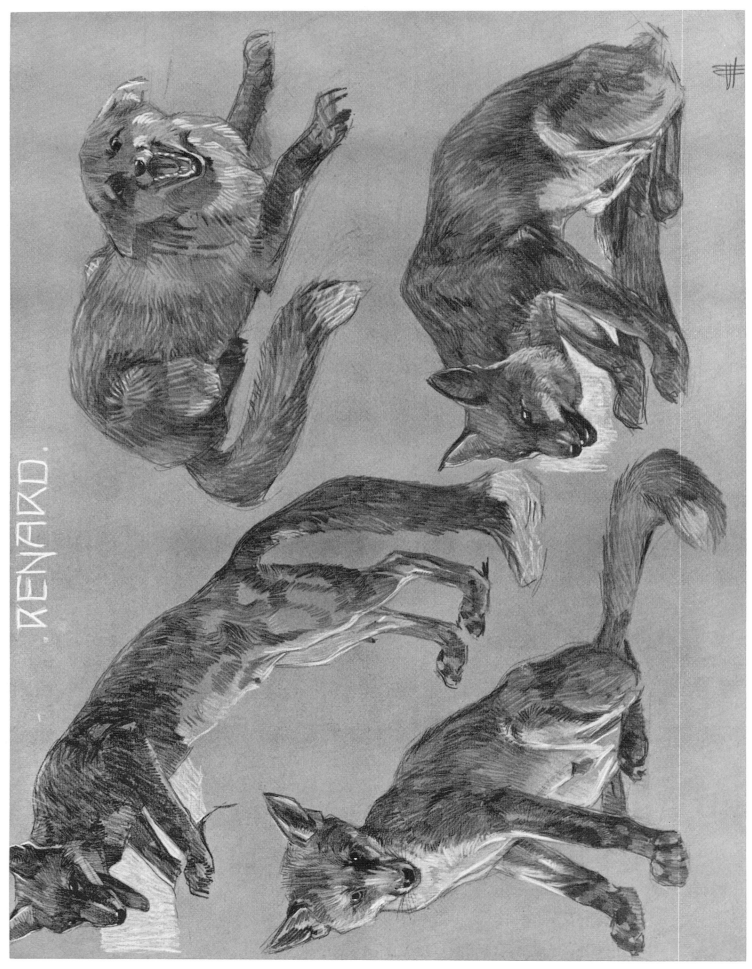

RENARD.

Fox

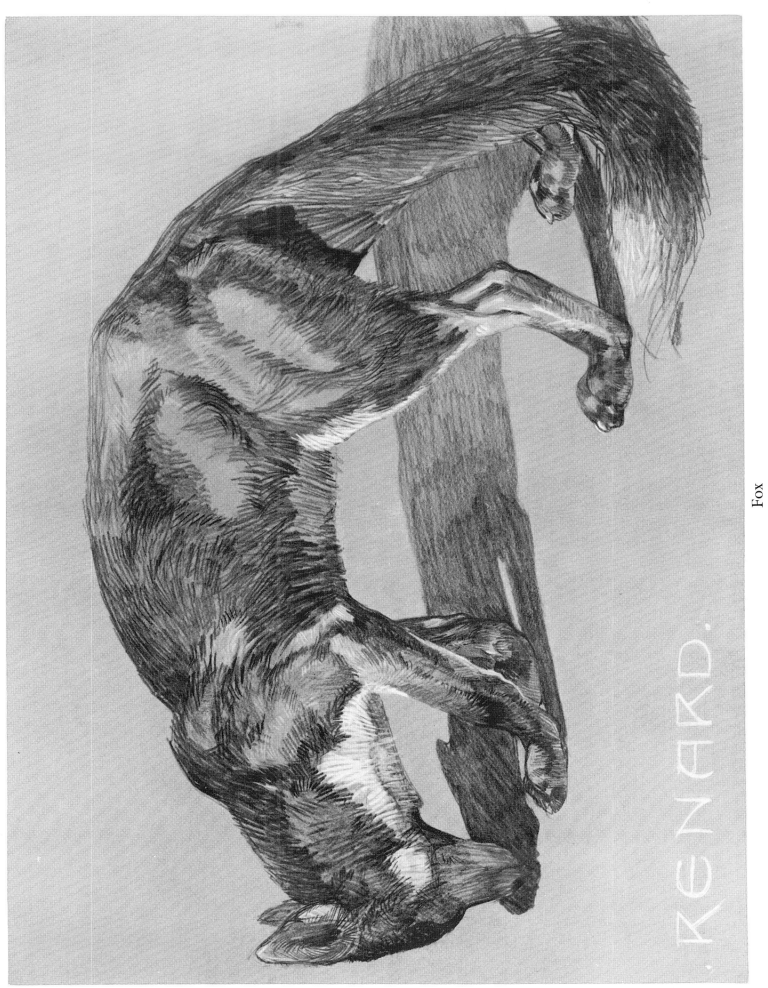

Fox

Plate 8 *Mammals*

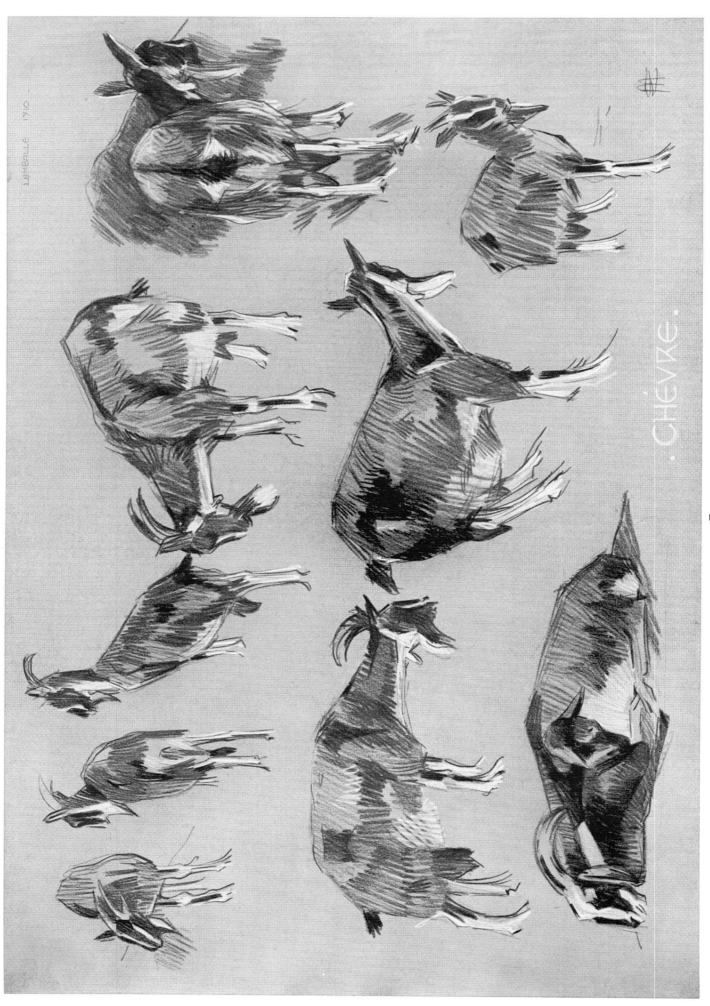

Goat

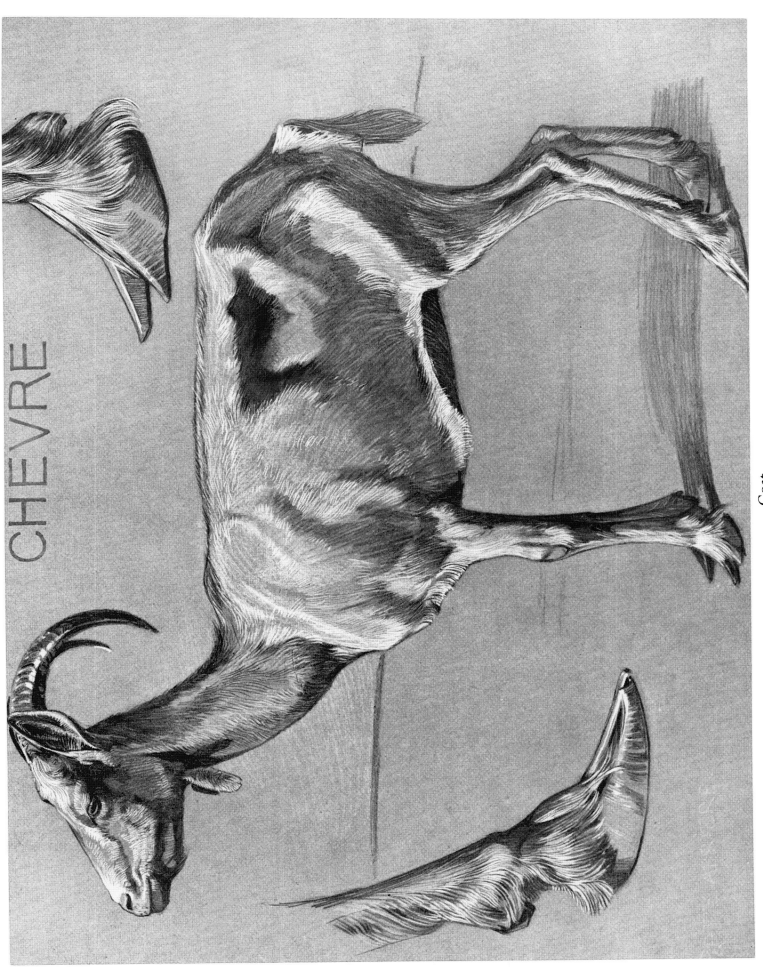

CHEVRE

Goat

Plate 10 *Mammals*

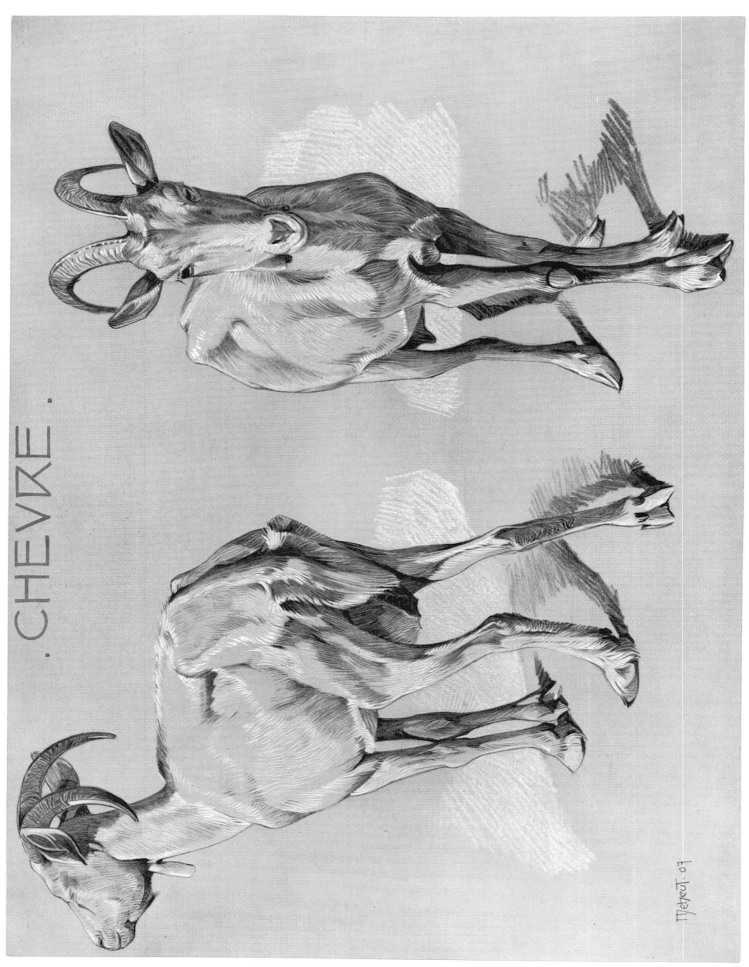

.CHEVRE.

Goat

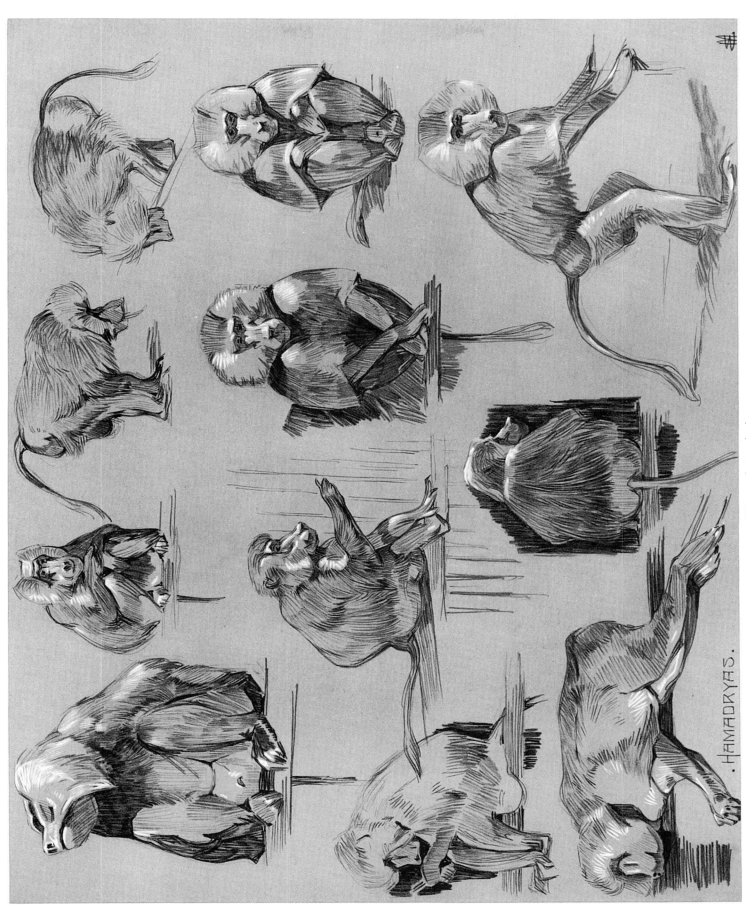

Hamadryas baboon

Plate 12 *Mammals*

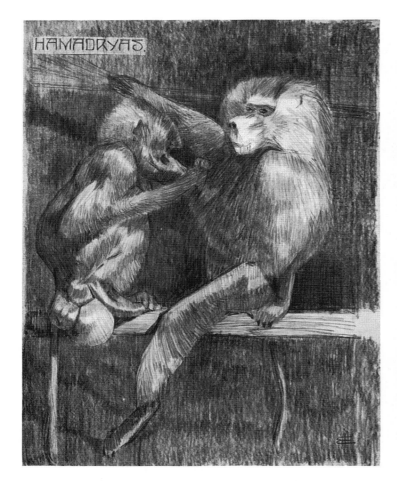

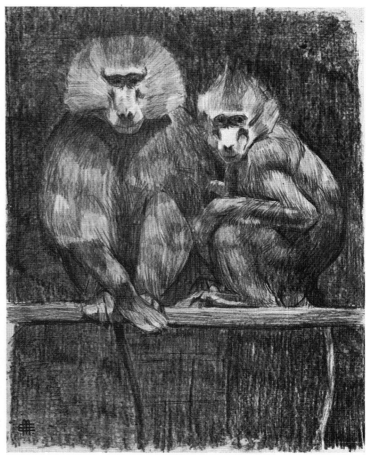

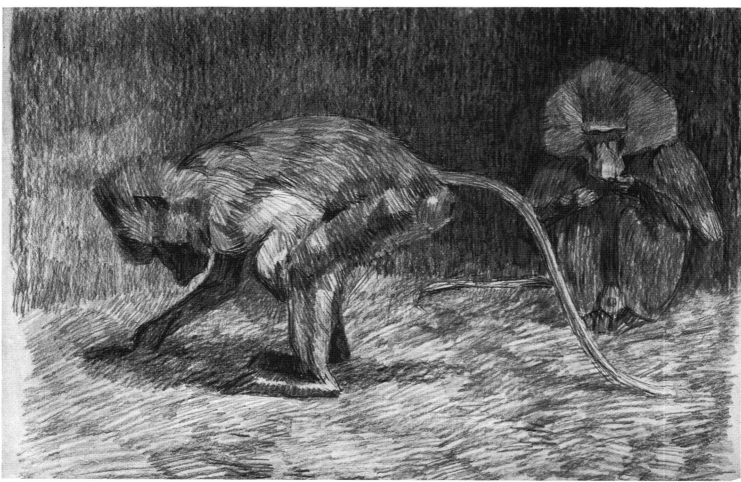

Hamadryas baboon

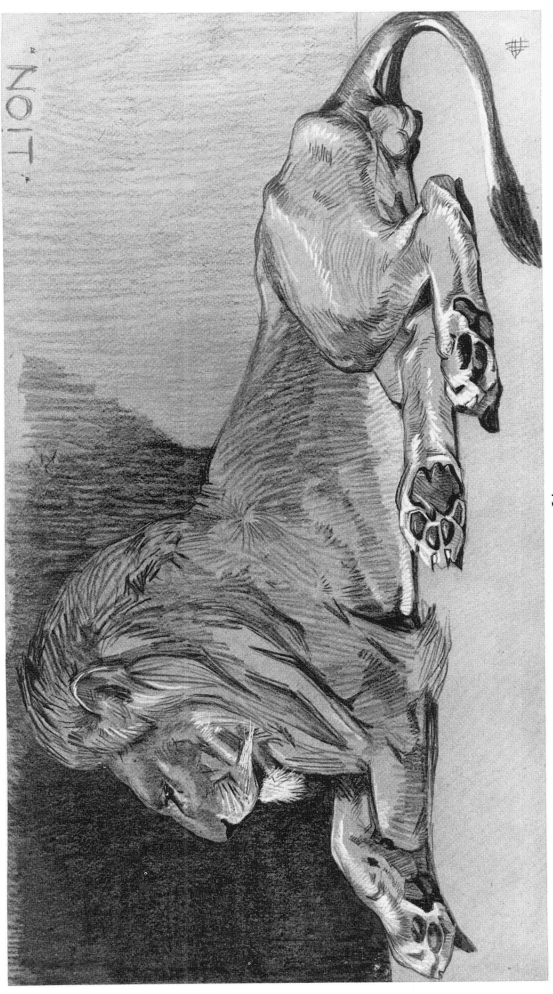

Lion

Plate 14 *Mammals*

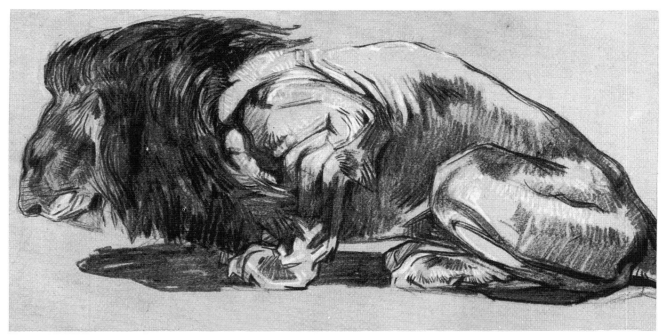

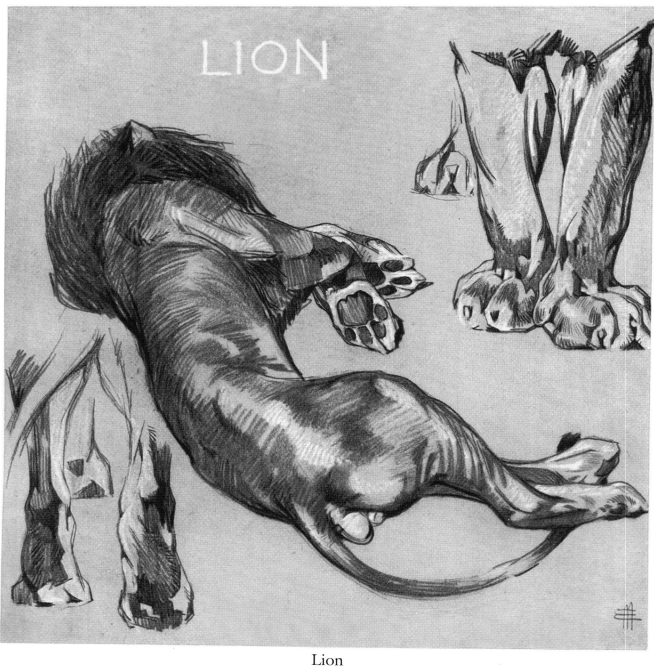

Lion

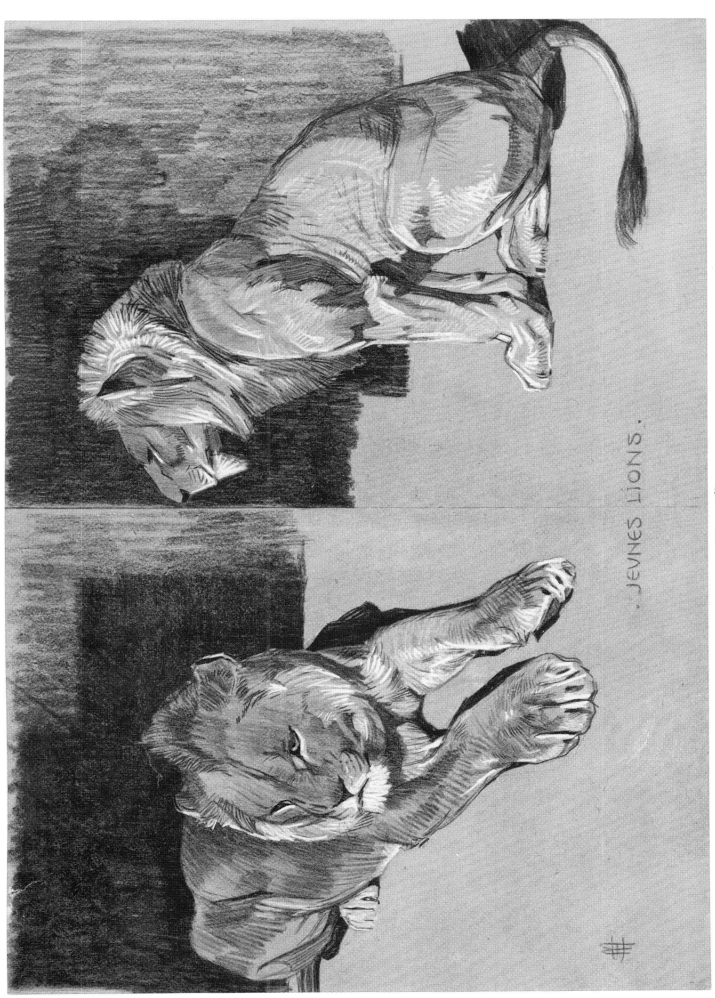

JEVNES LIONS.

Young lions

Plate 16 *Mammals*

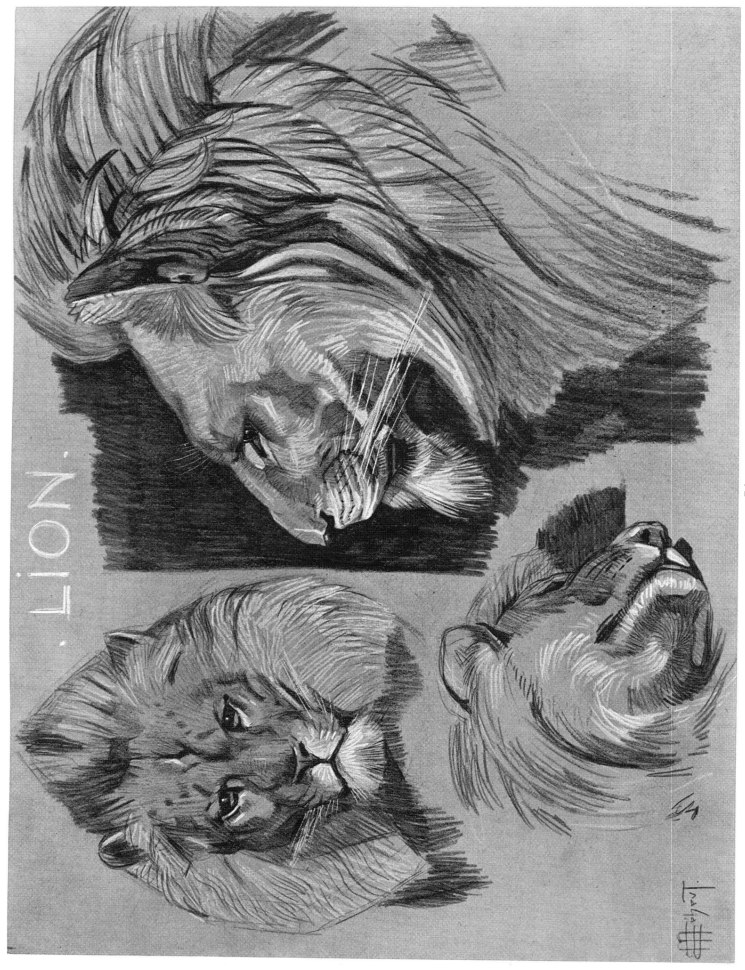

Lion

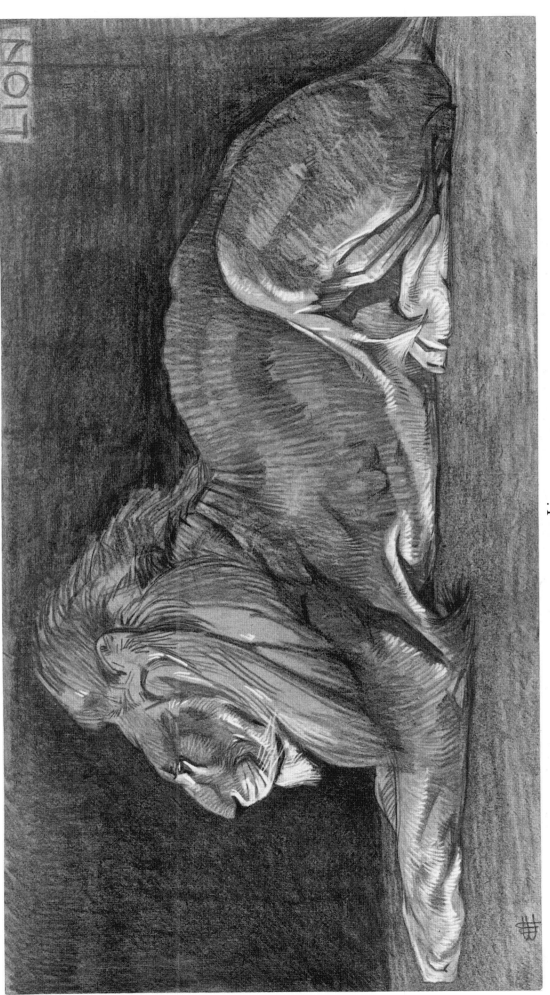

Lion

Plate 18 *Mammals*

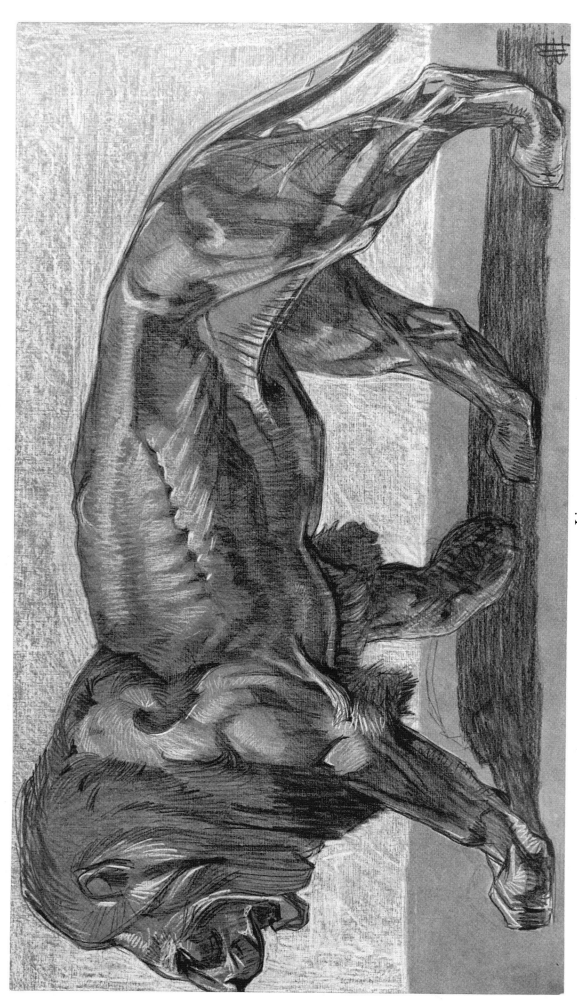

Lion

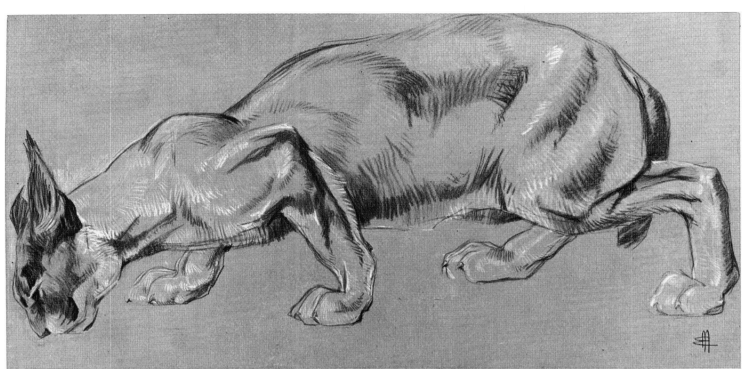

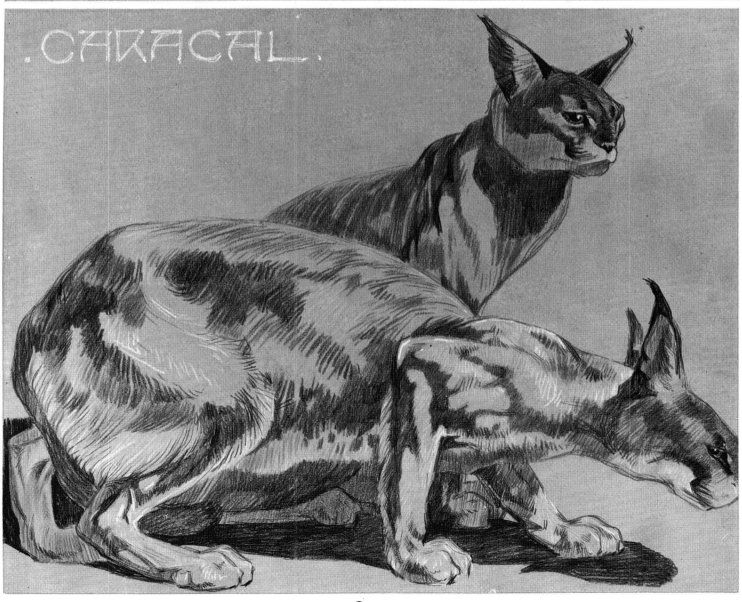

Lynx

Plate 20 *Mammals*

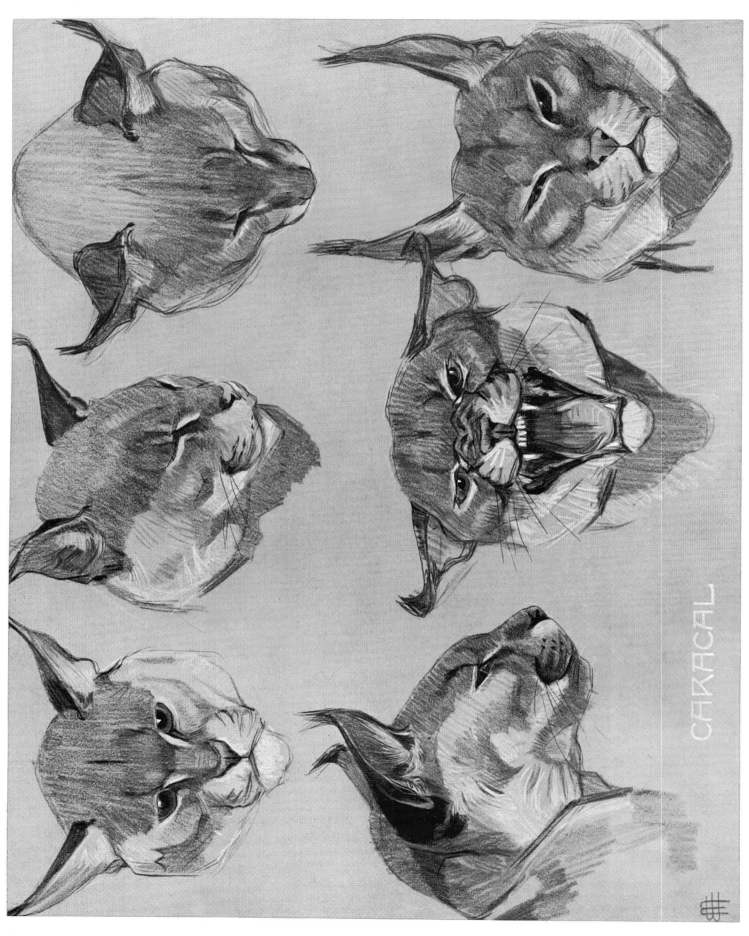

Lynx

CARACAL

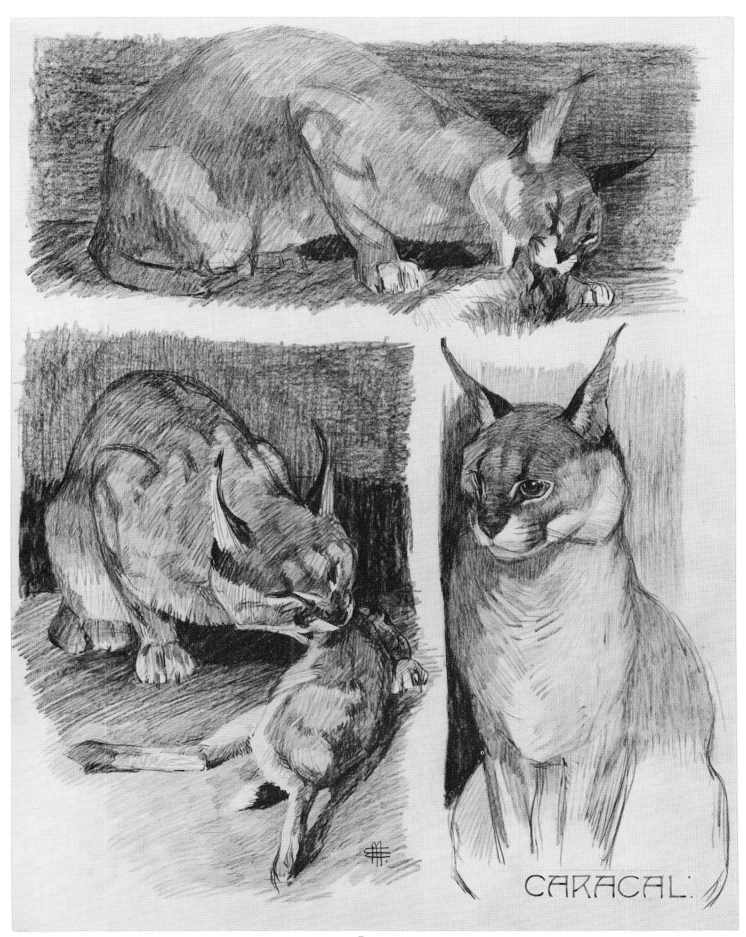

Lynx

Plate 22 *Mammals*

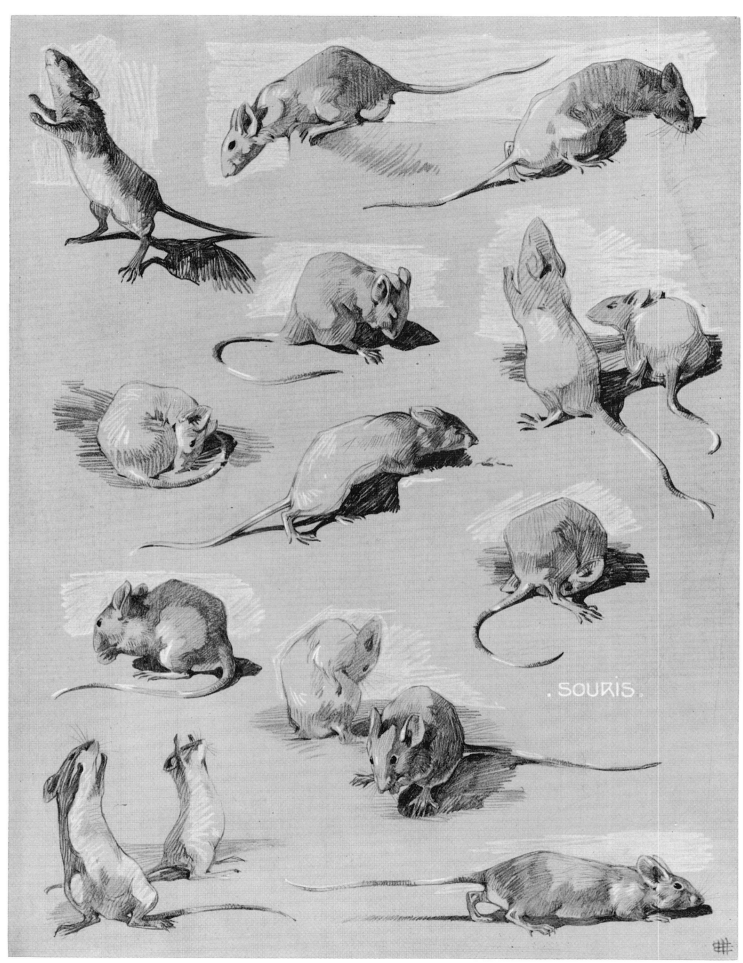

Mouse

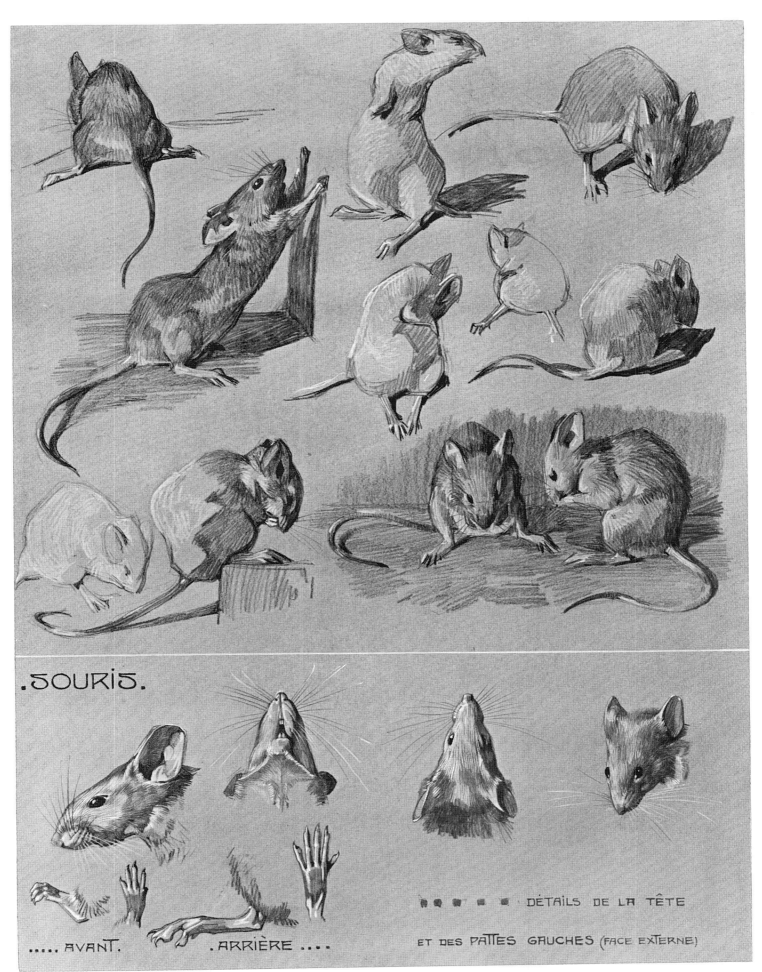

.SOURIS.

..... AVANT. .ARRIÈRE

DÉTAILS DE LA TÊTE

ET DES PATTES GAUCHES (FACE EXTERNE)

Mouse

Plate 24 *Mammals*

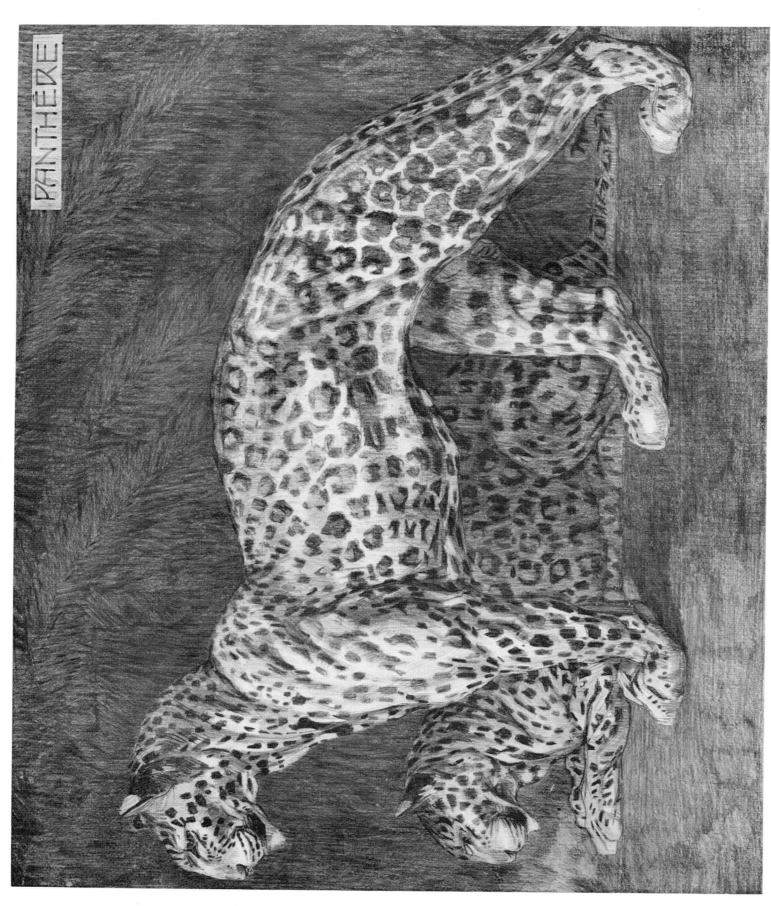

Panther

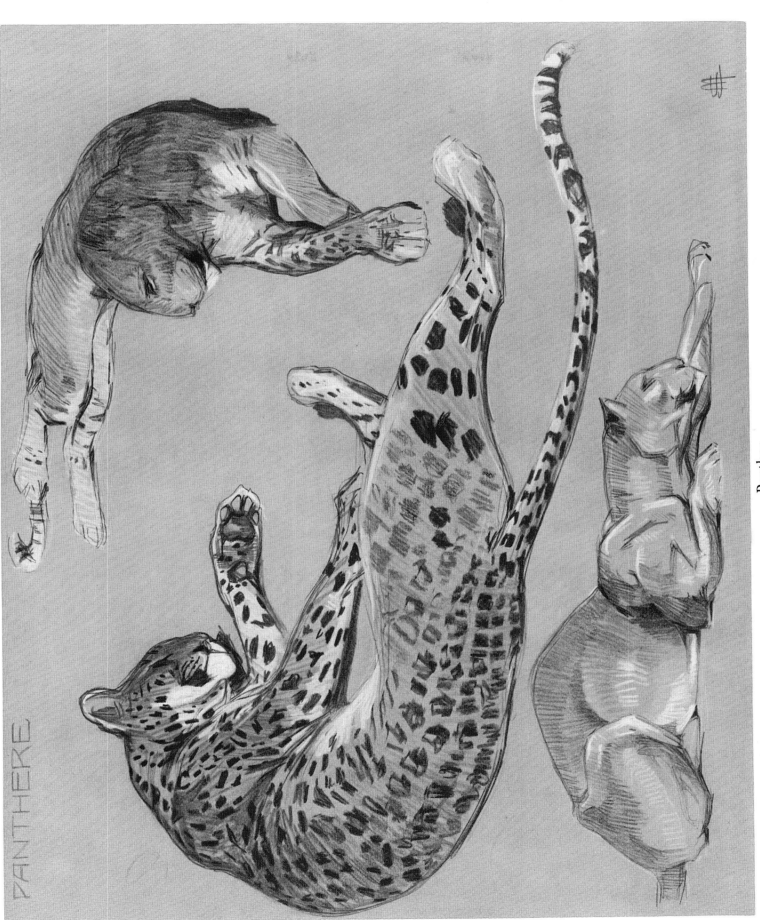

PANTHERE

Panther

Plate 26 *Mammals*

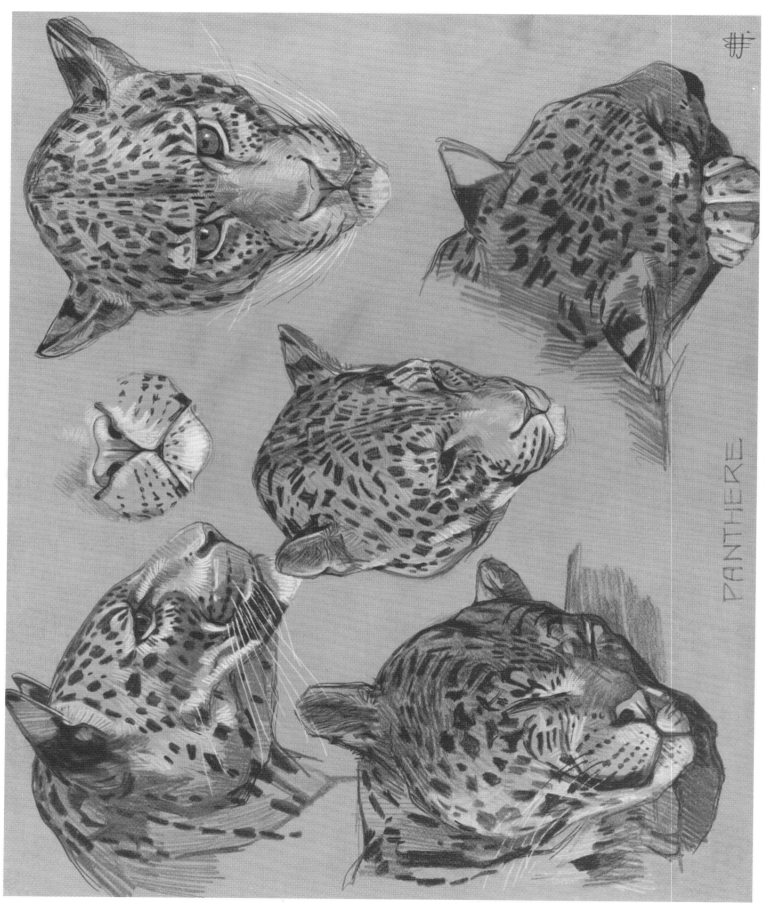

PANTHERE

Panther

Plate 26

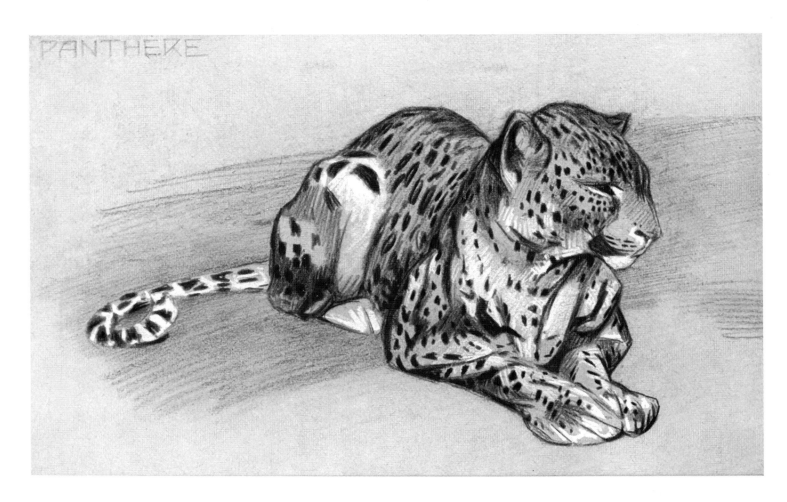

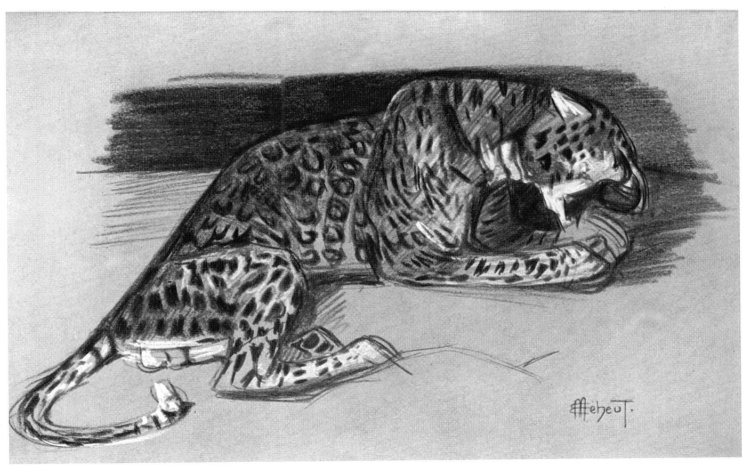

Panther

Plate 28 *Mammals*

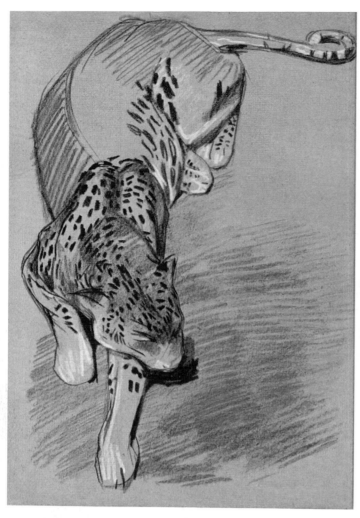

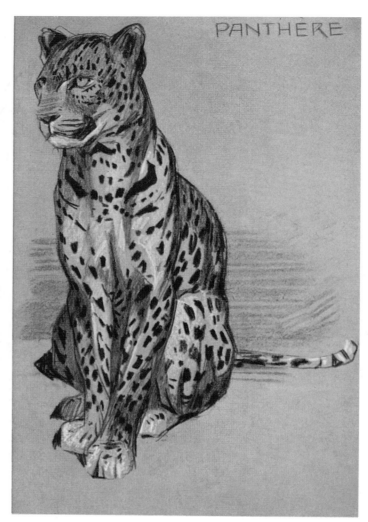

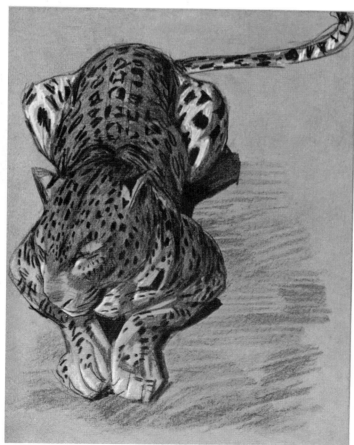

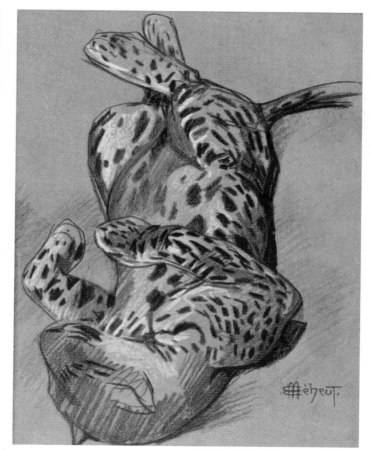

Panther

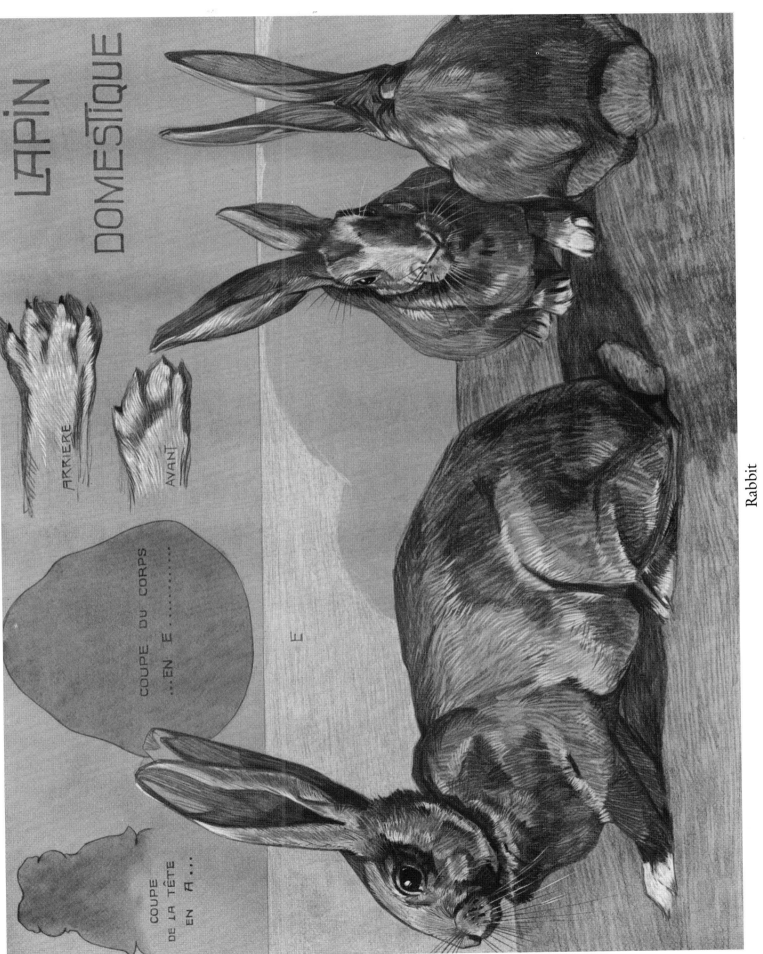

LAPIN DOMESTIQUE

ARRIÈRE

AVANT

COUPE DU CORPS ...EN E

COUPE DE LA TÊTE EN A...

Rabbit

Plate 30 *Mammals*

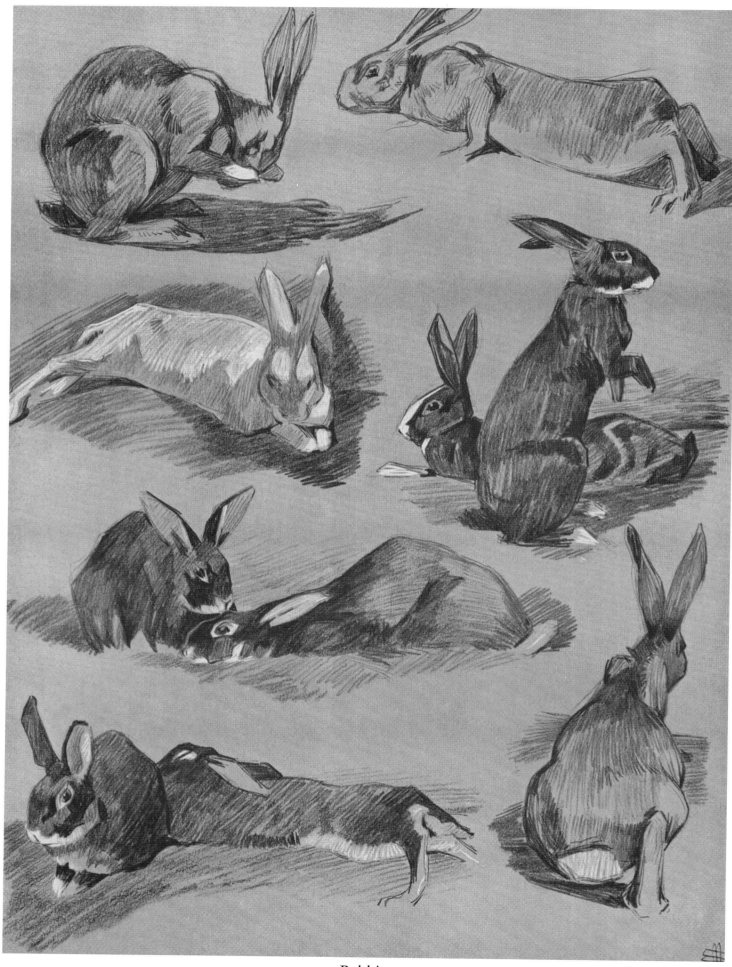

Rabbit

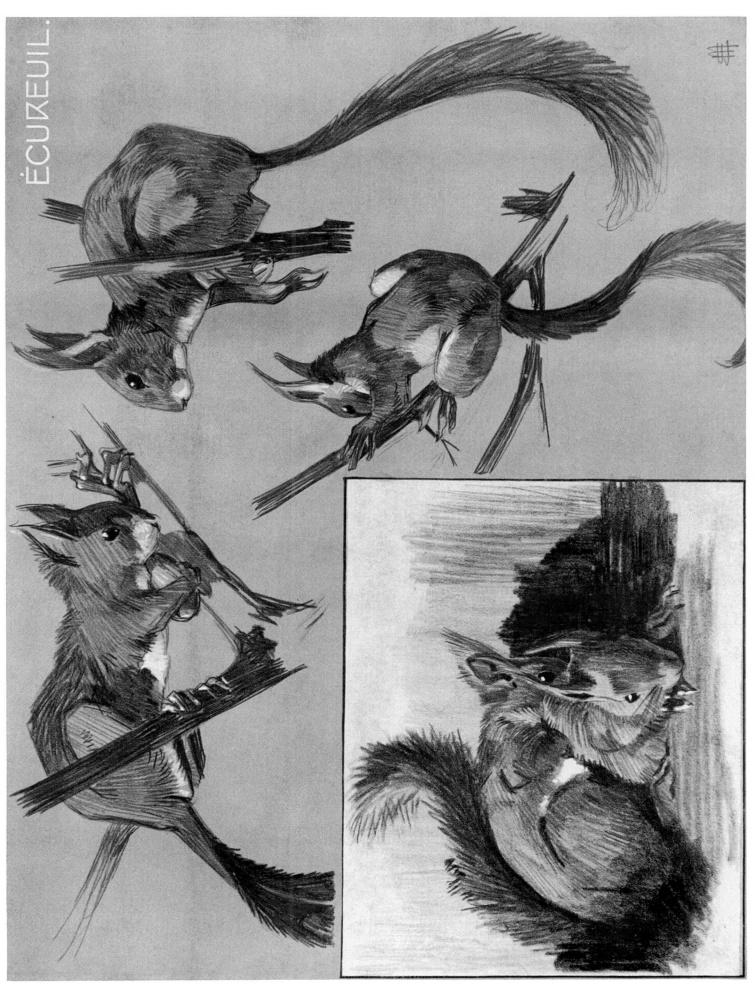

ÉCUREUIL.

Squirrel

Plate 32 *Mammals*

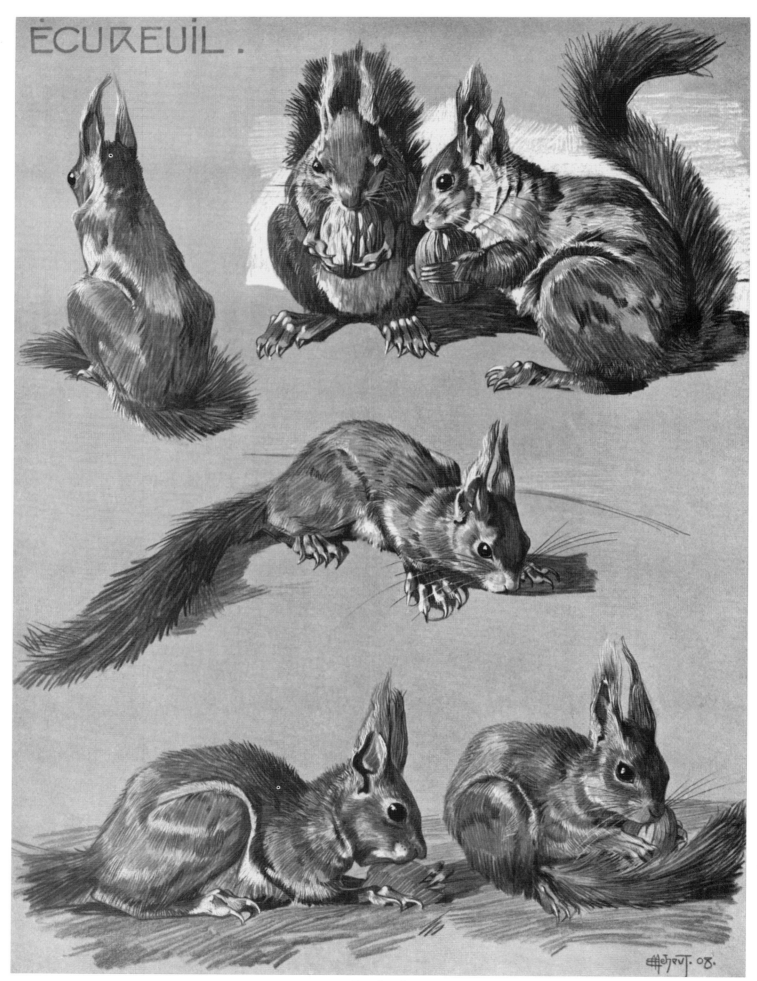

Squirrel

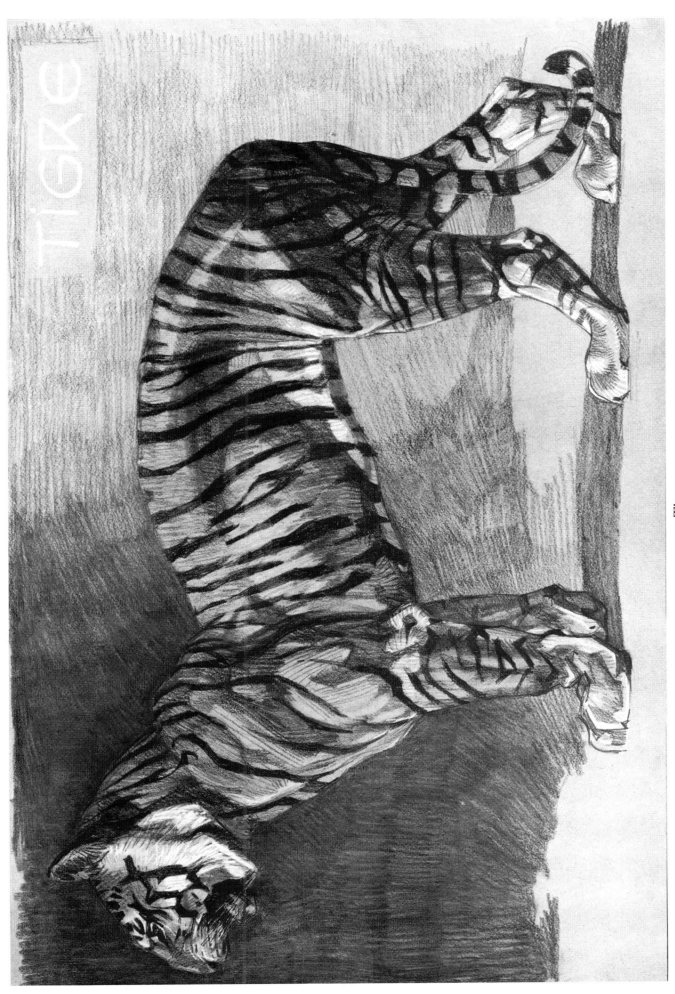

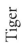

Tiger

Plate 34 *Mammals*

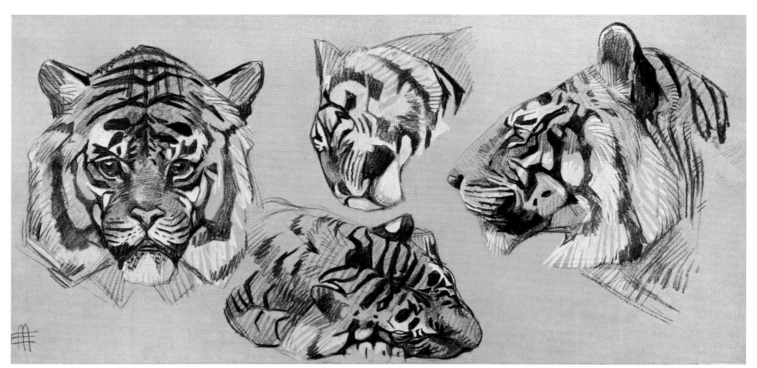

Tigers

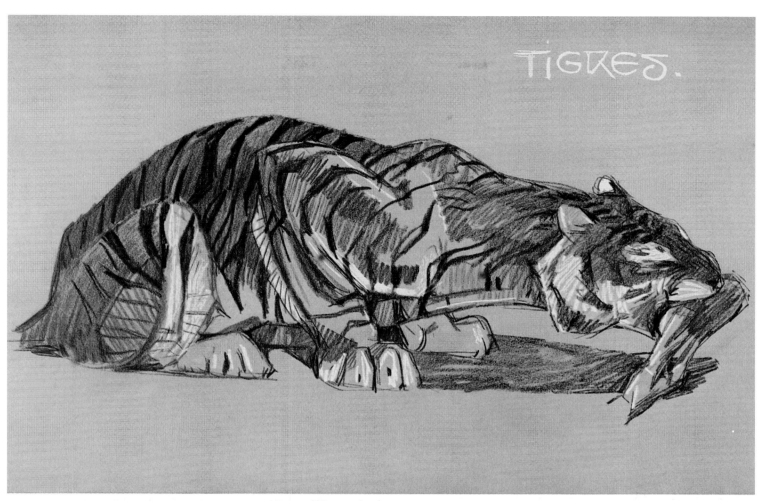

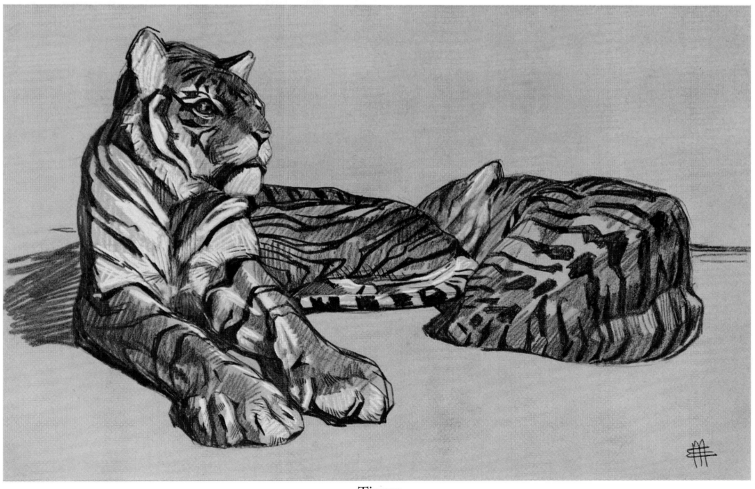

Tigers

Plate 36 *Mammals*

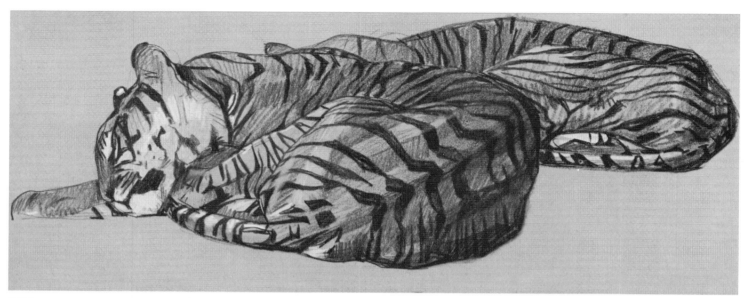

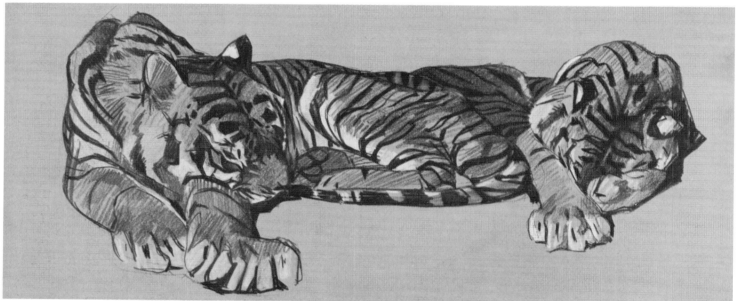

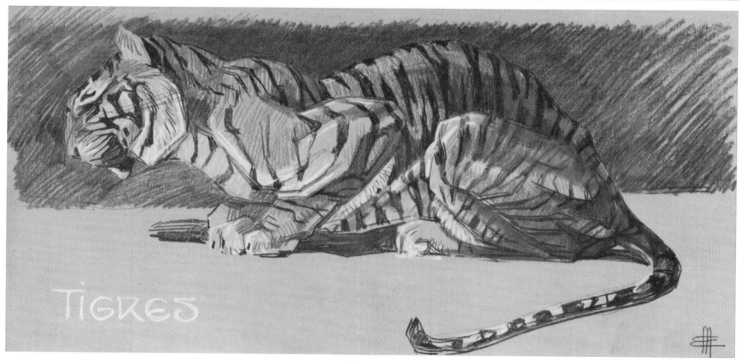

Tigers

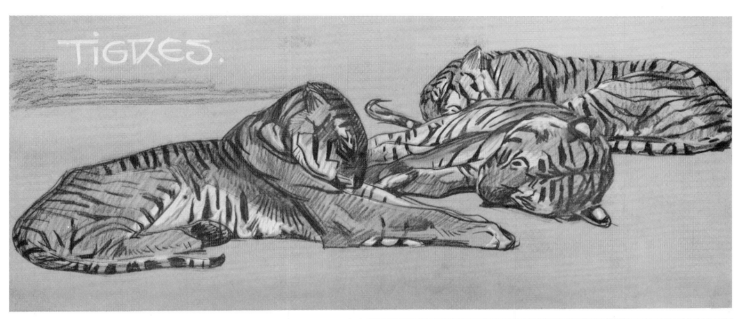

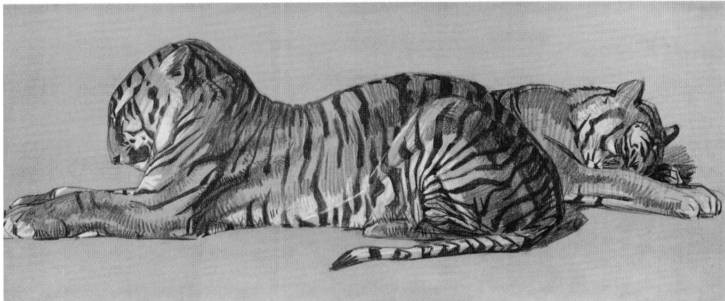

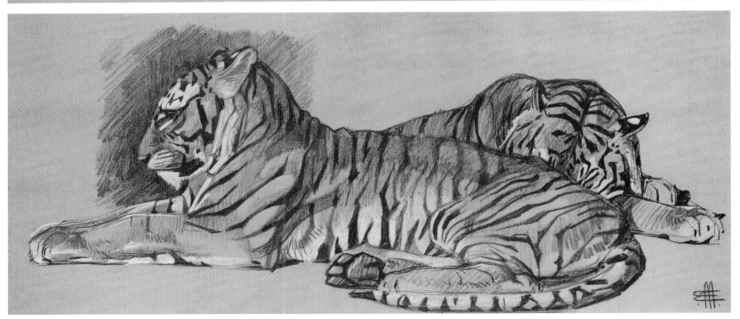

Tigers

Plate 38 *Mammals*

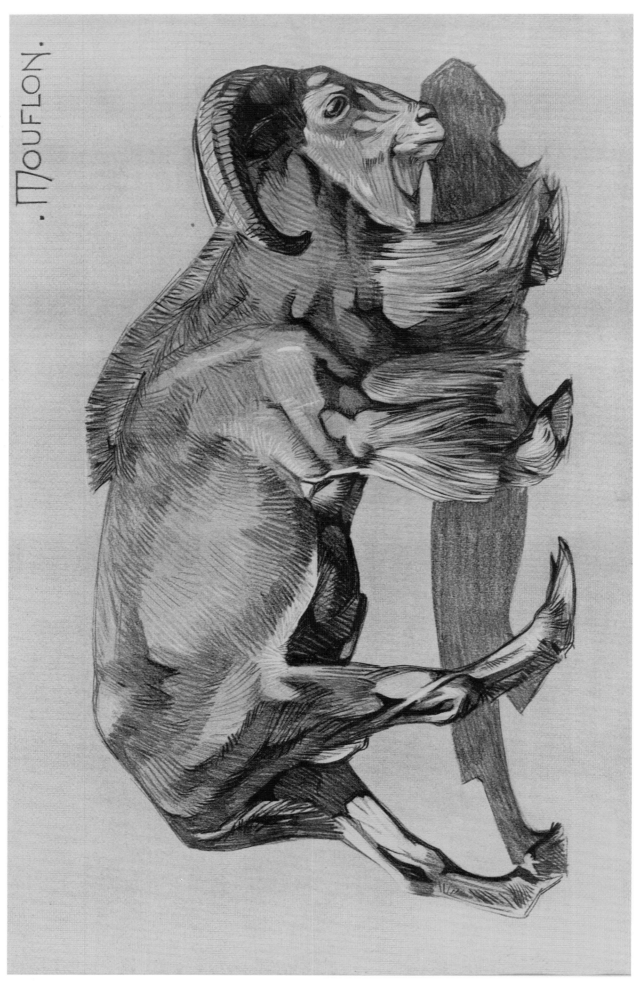

MOUFLON.

Wild sheep

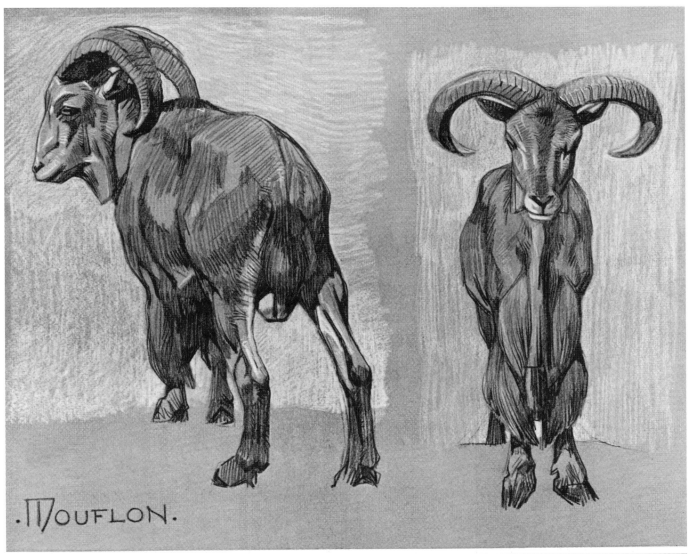

.MOUFLON.

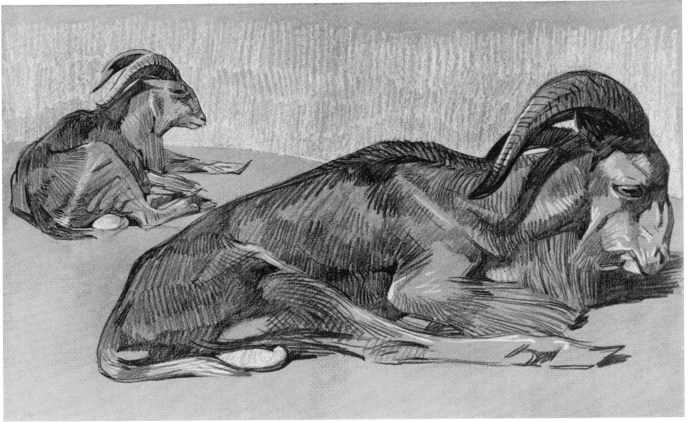

Wild sheep

Plate 40 *Mammals*

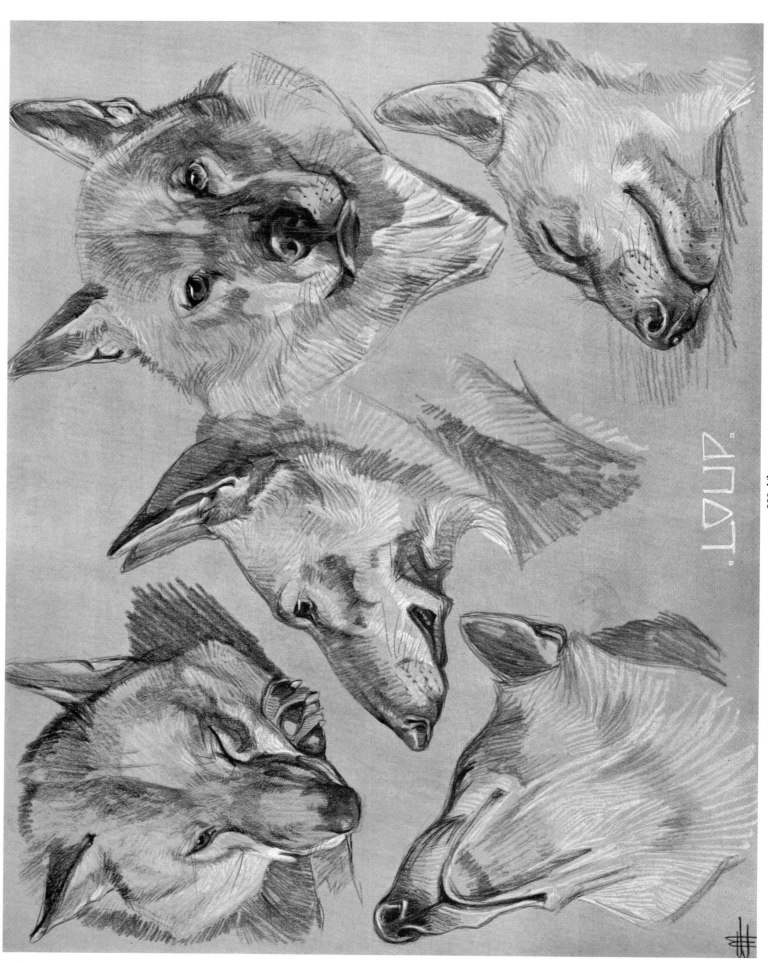
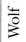

Wolf

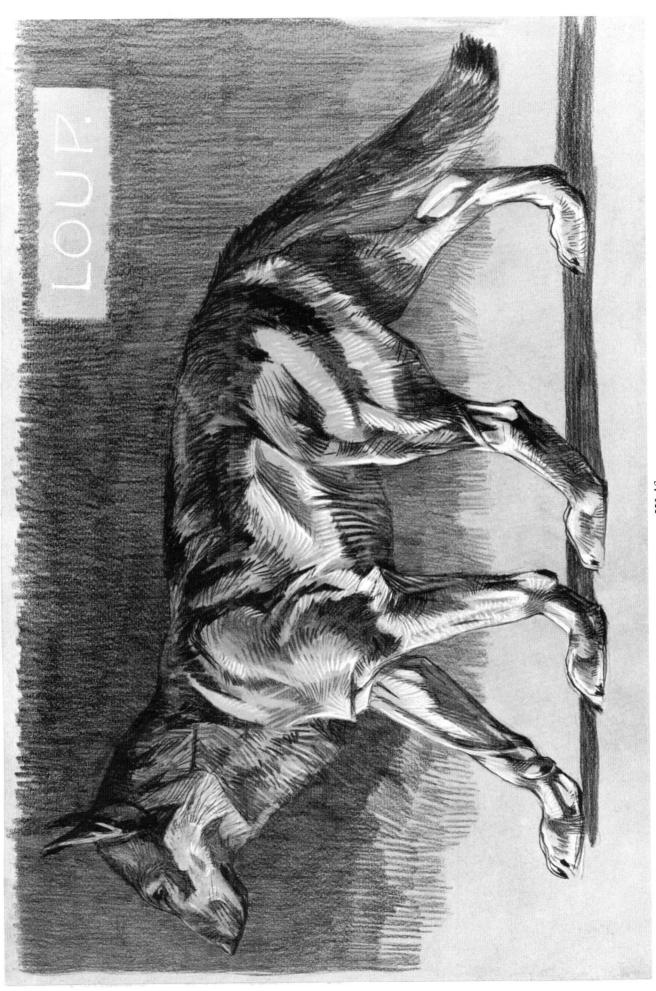

Wolf

Plate 42 *Mammals*

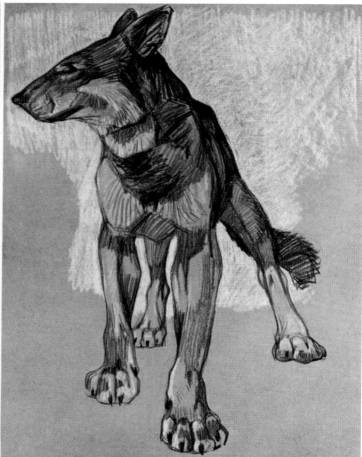

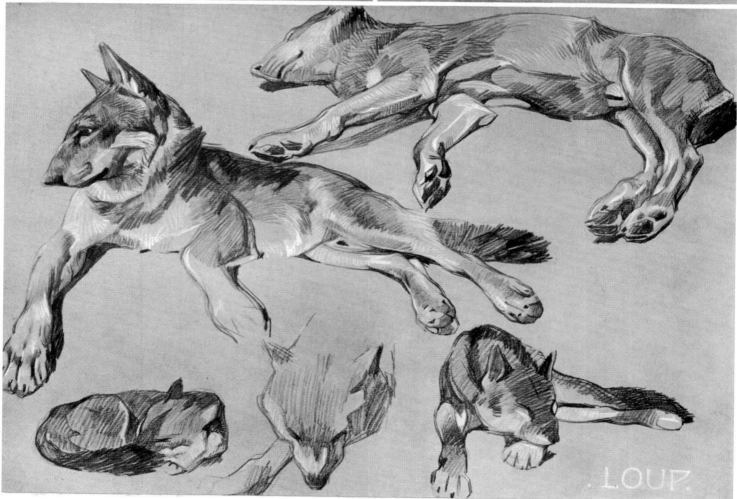

Wolf

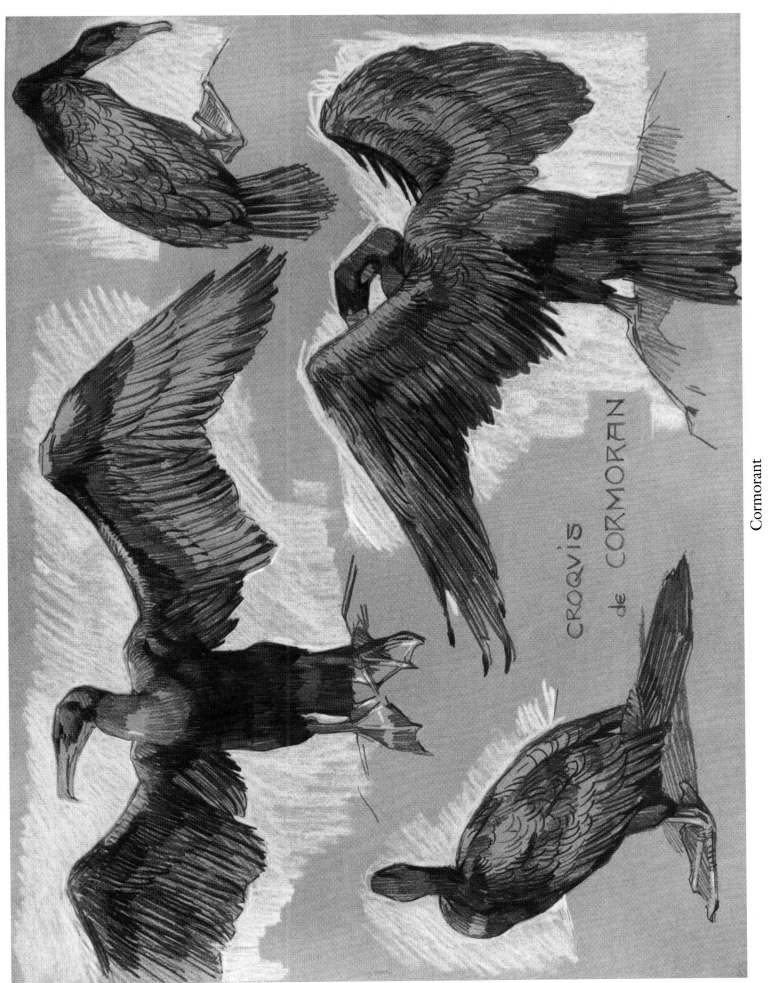

CROQVIS de CORMORAN

Cormorant

Plate 44 *Birds*

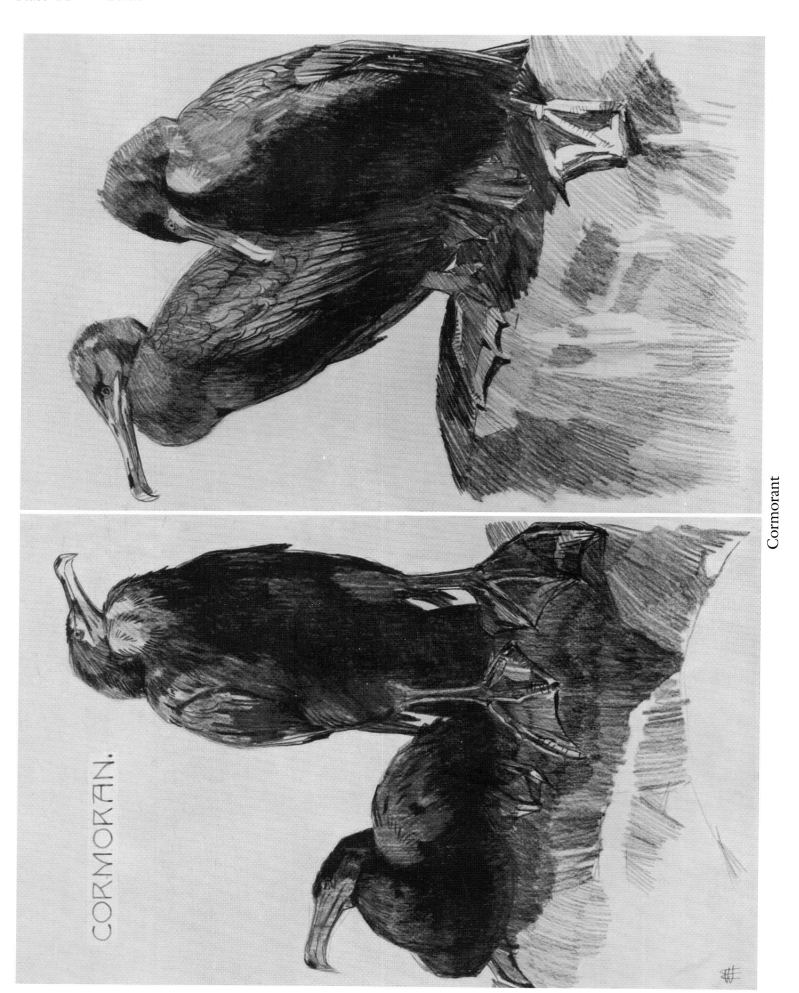

CORMORAN.

Cormorant

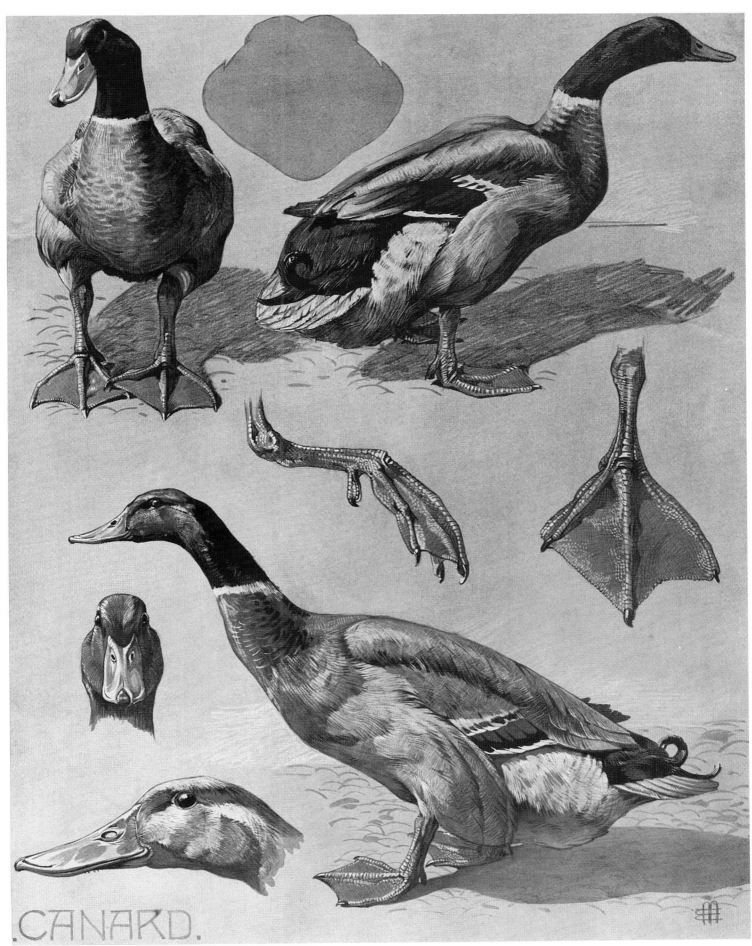

CANARD.

Duck

Plate 46 *Birds*

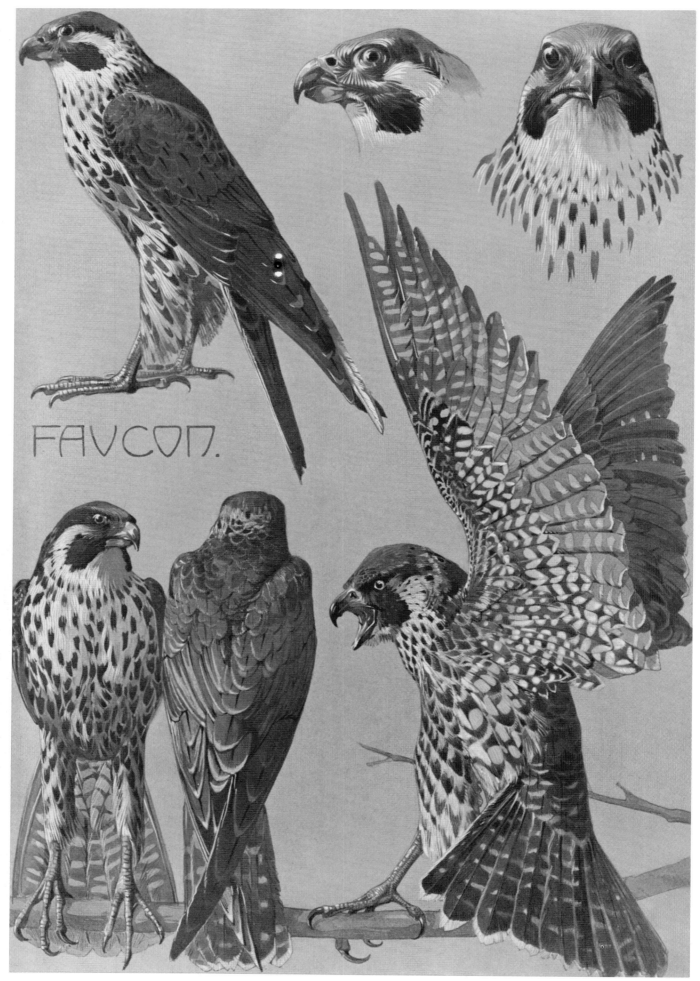

Falcon

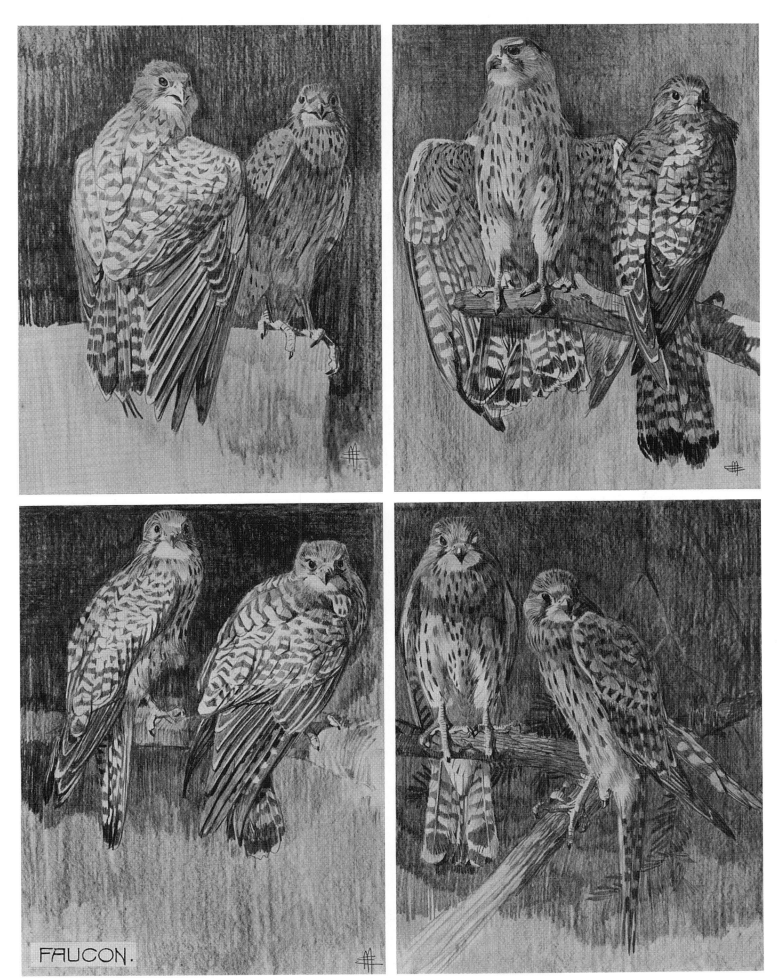

FAUCON.

Falcon

Plate 48 *Birds*

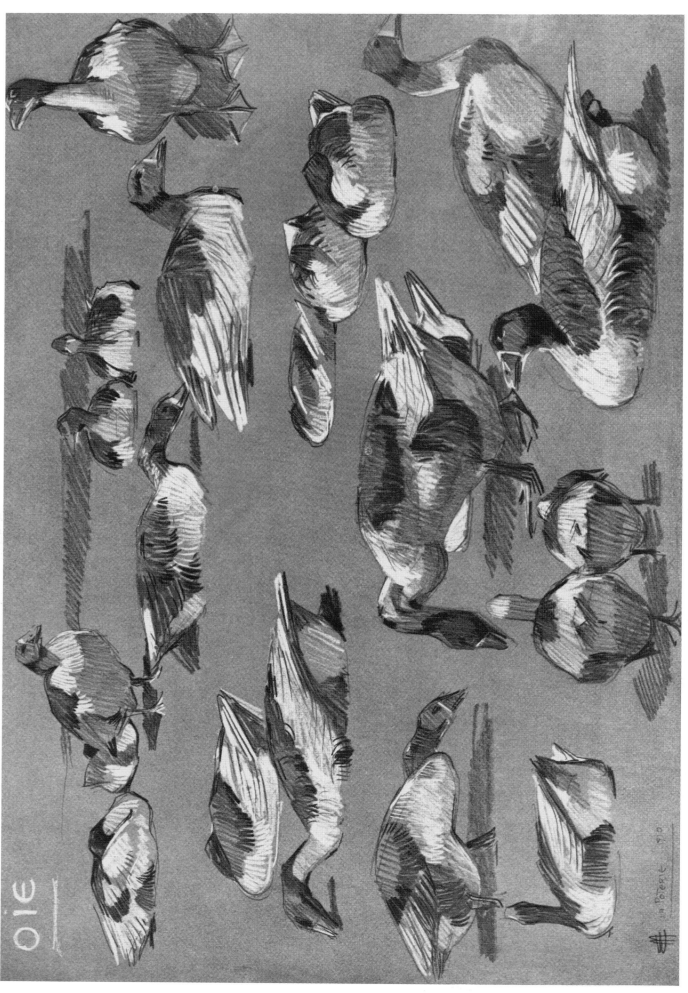

Goose

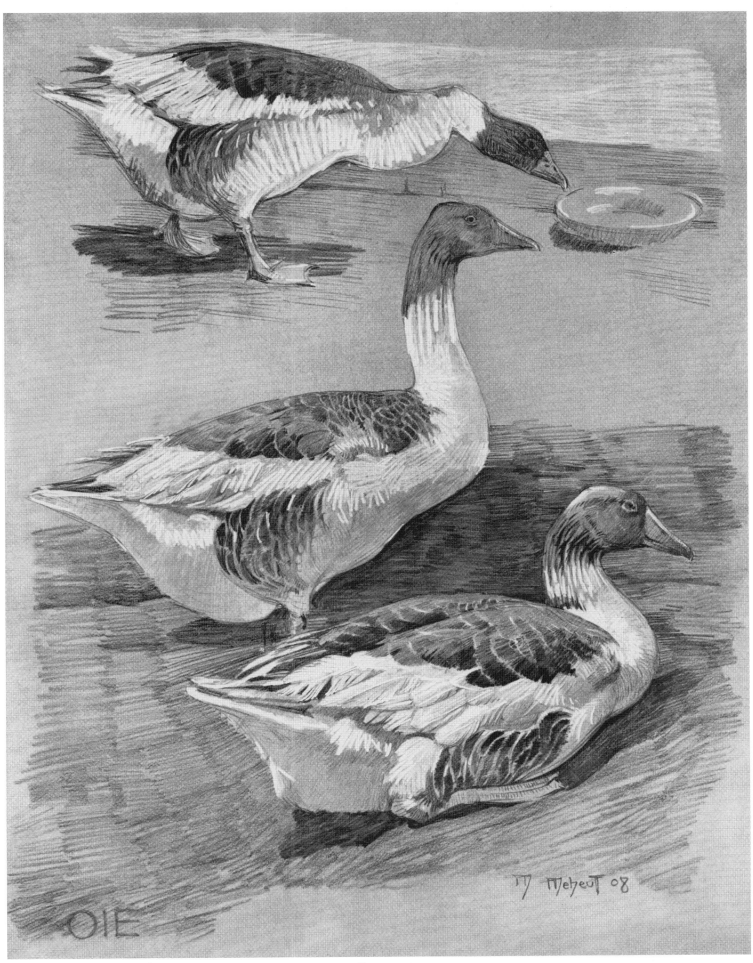

Goose

Plate 50 *Birds*

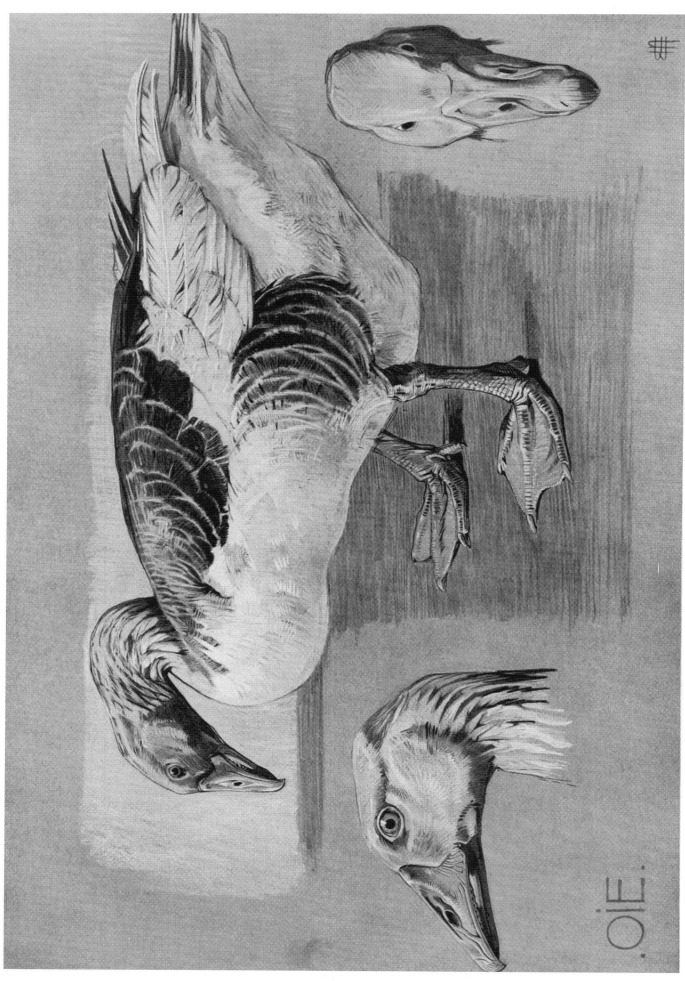

Goose

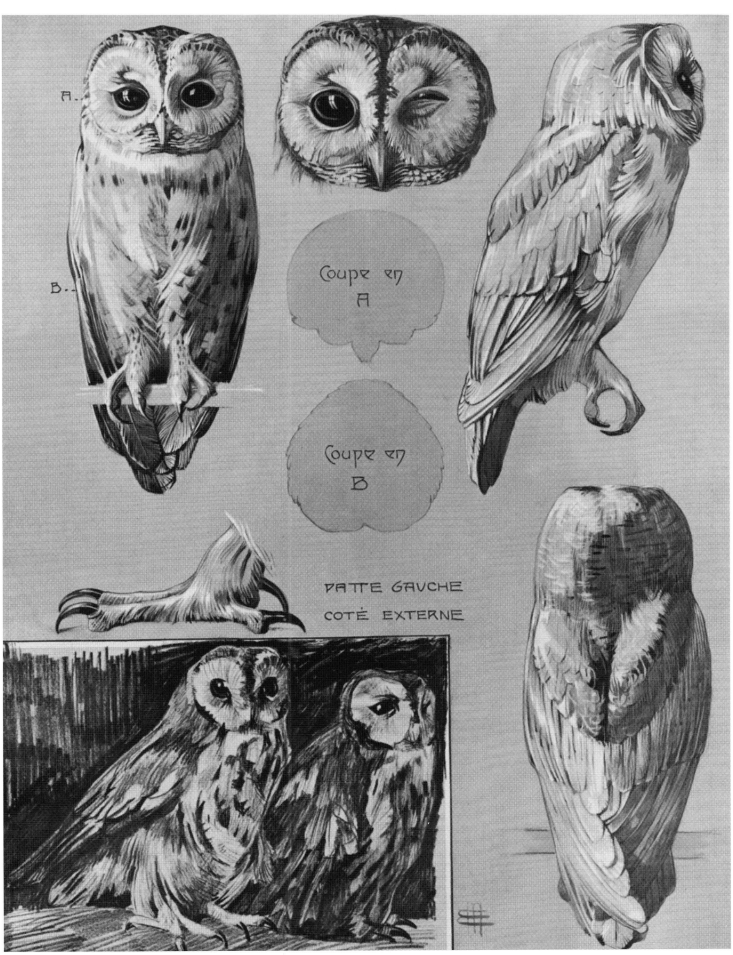

Coupe en A

Coupe en B

PATTE GAVCHE
COTÉ EXTERNE

Owl

Plate 52 *Birds*

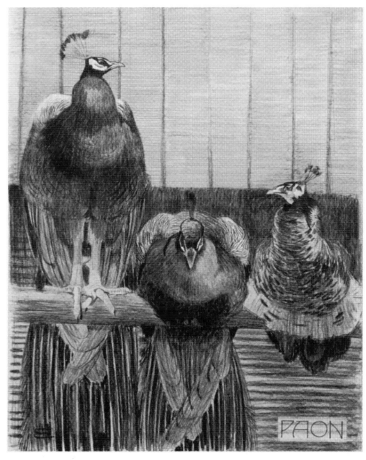

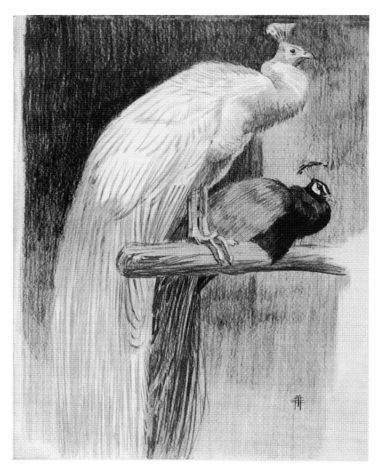

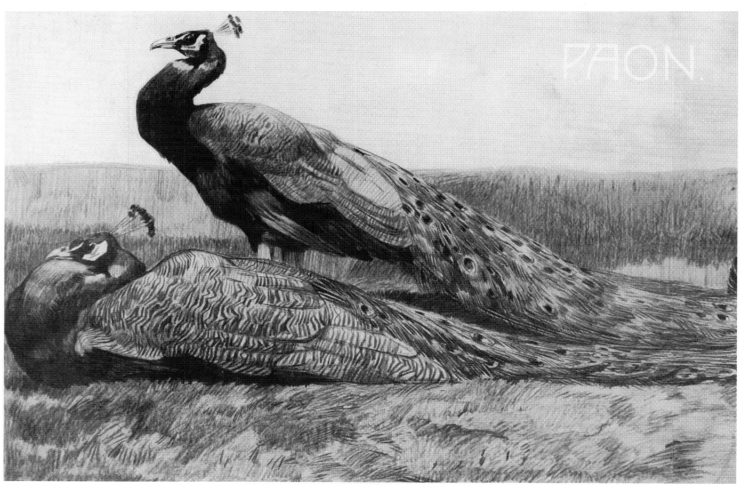

Peacock

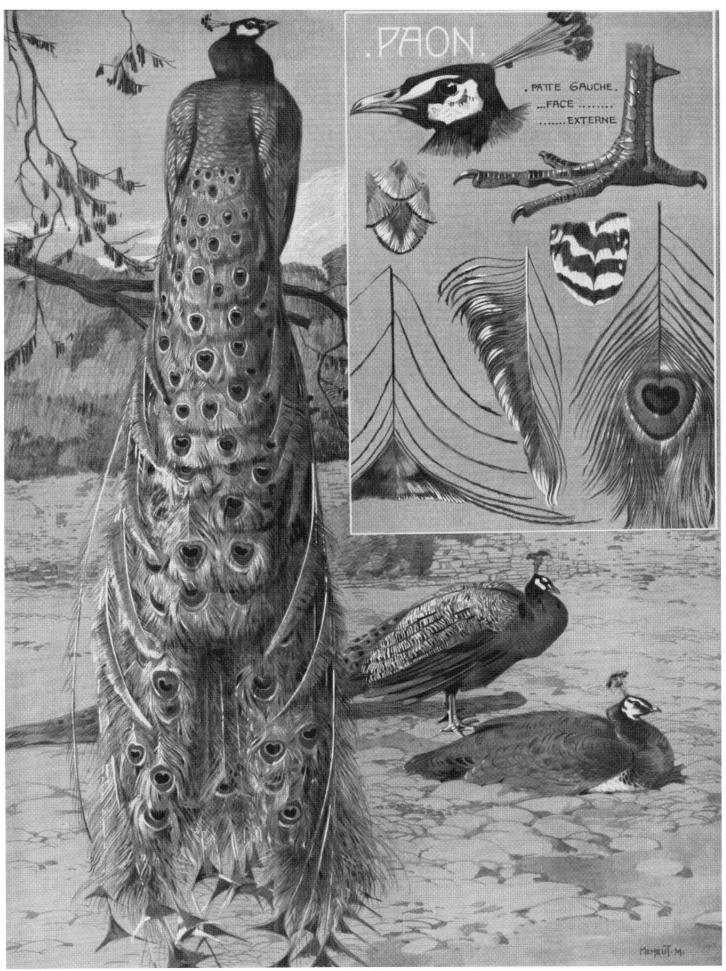

Peacock

Plate 54 *Birds*

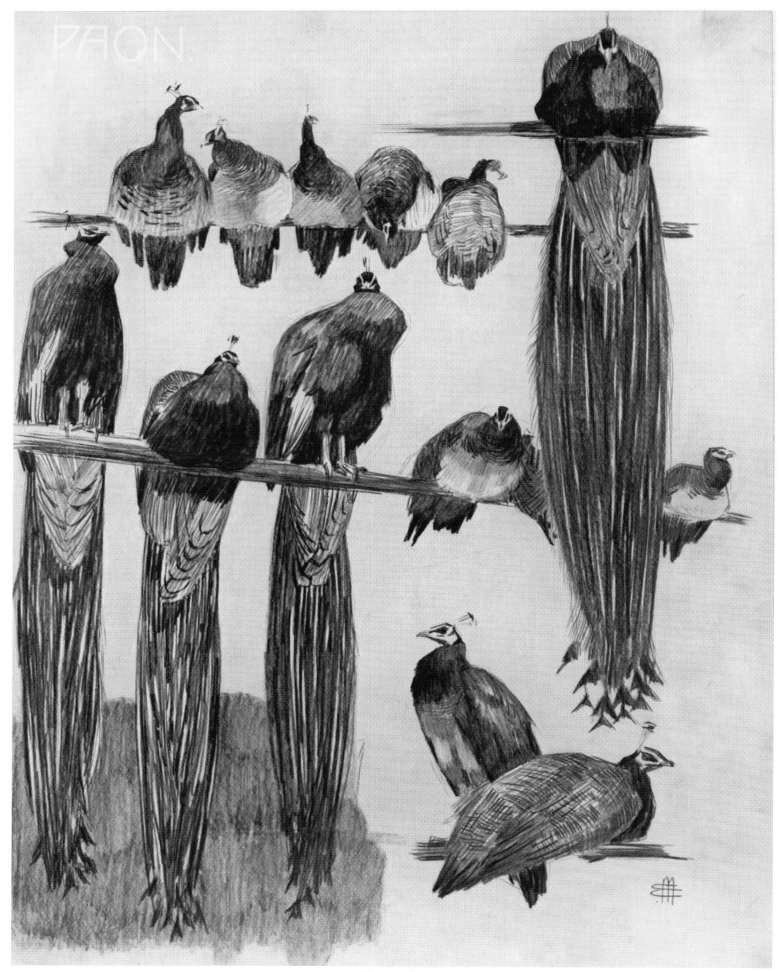

Peacock

PAON

ÉTUDE GÉOMÉTRIQUE,
DE L'EMPLACEMENT DES YEUX
I & 2 PROFIL ET VUE POSTÉRIEURE
DU PAON A LA ROUE

Peacock

Plate 56 *Birds*

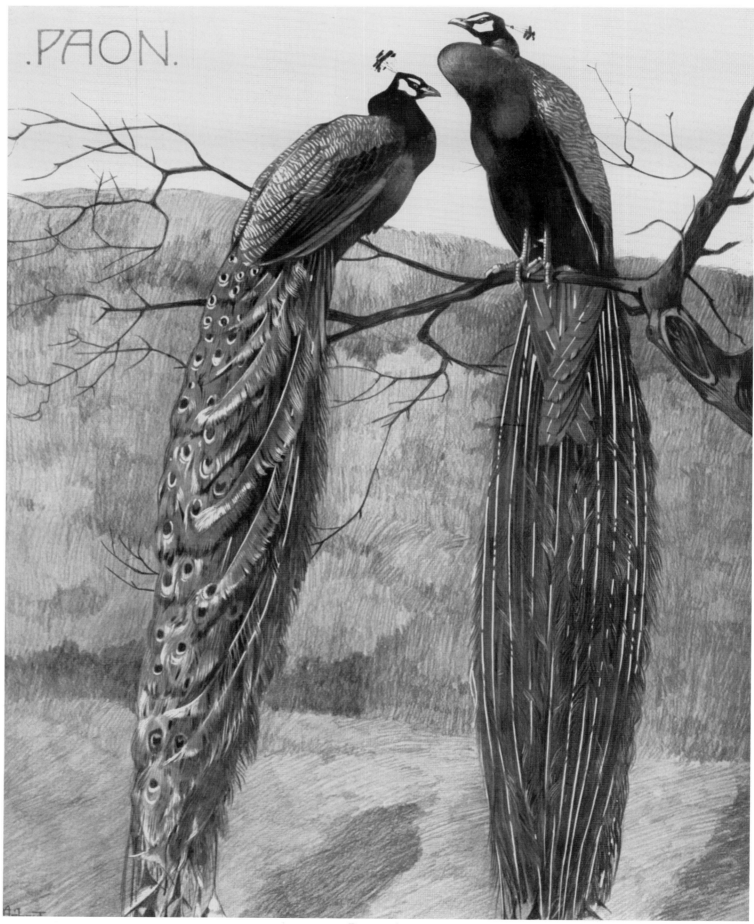

Peacock

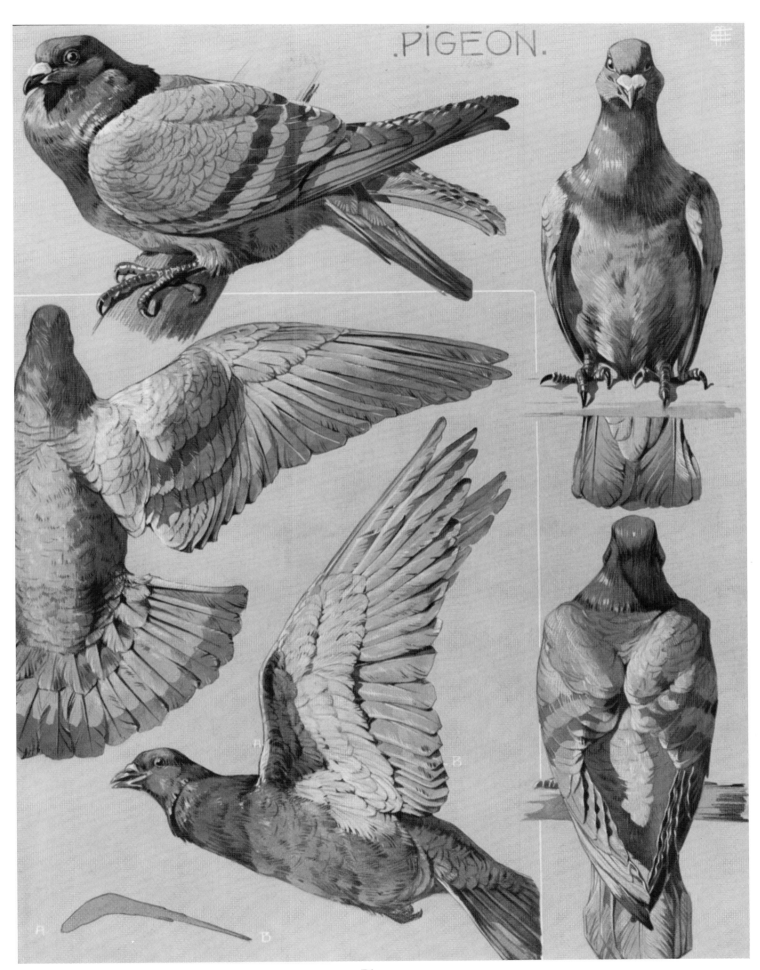

Pigeon

Plate 58 *Birds*

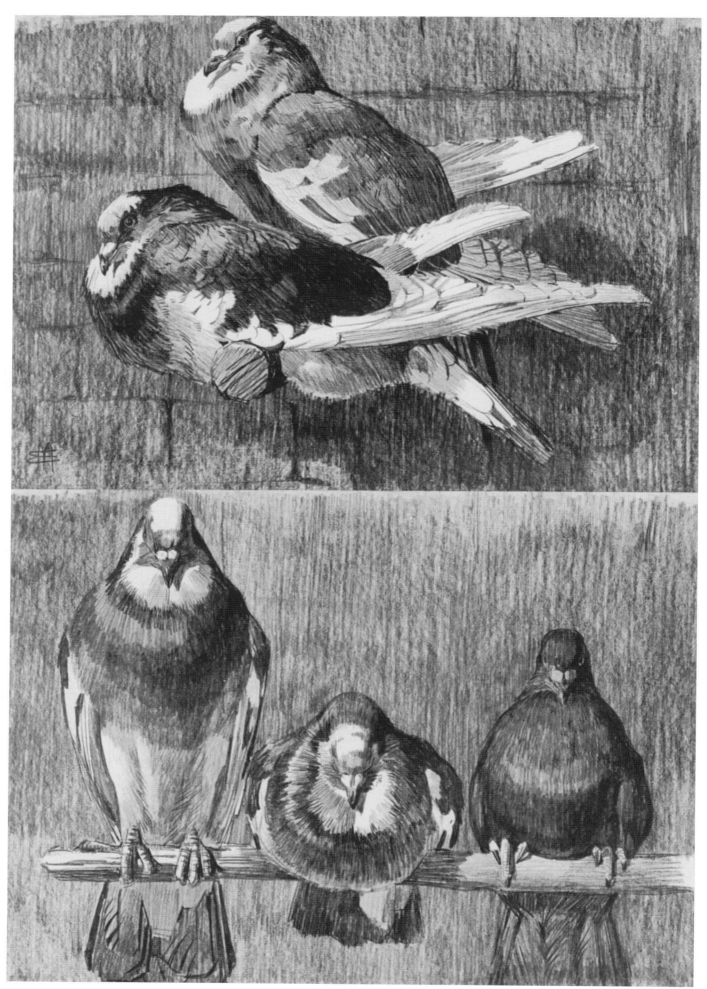

Pigeon

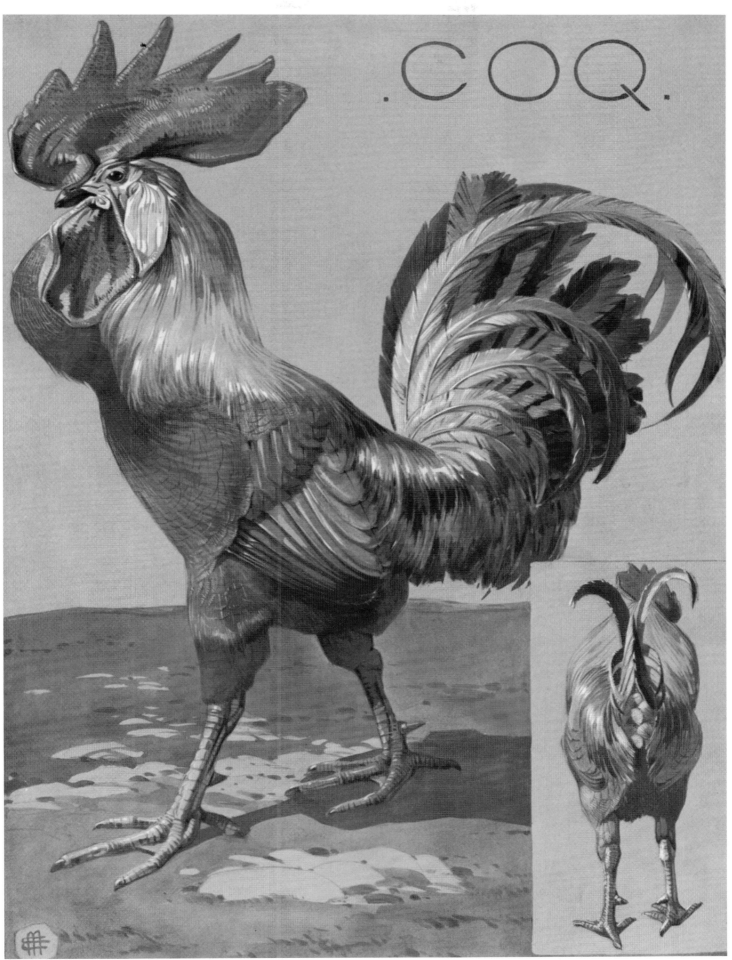

.COQ.

Rooster

Plate 60 *Birds*

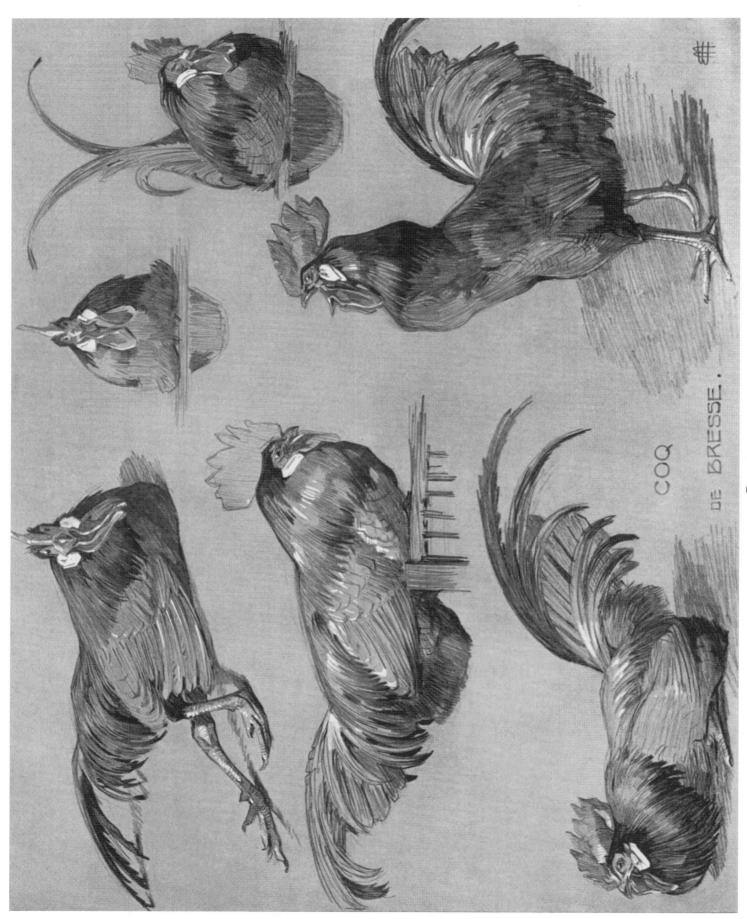

COQ ᴅᴇ BRESSE.

Rooster

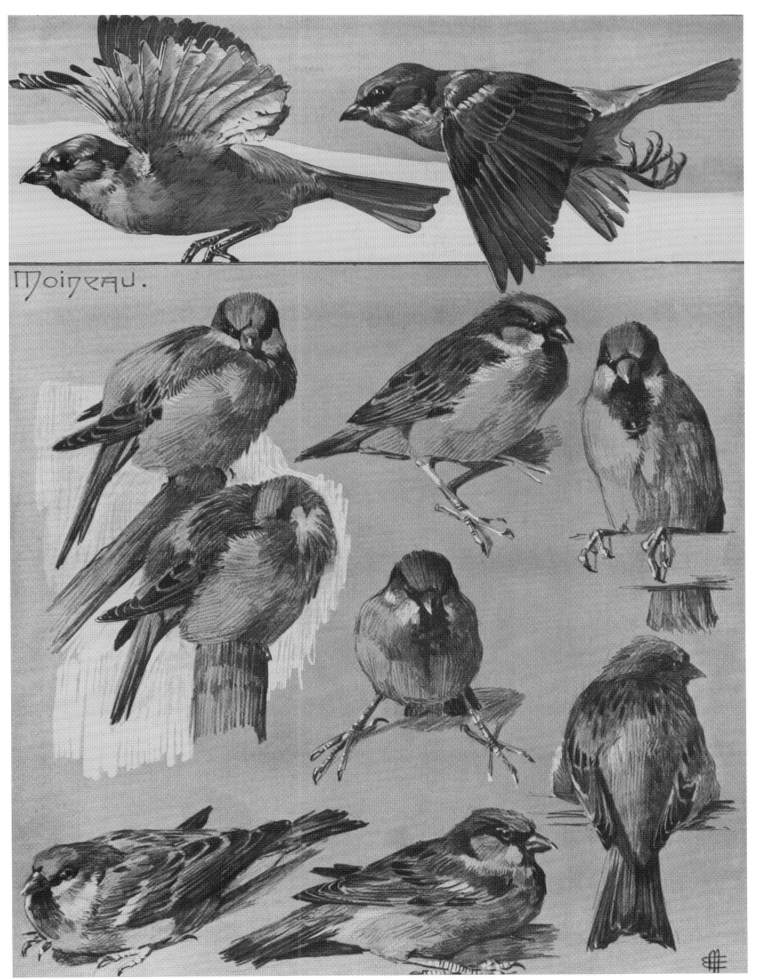

Moineau.

Sparrow

Plate 62 *Birds*

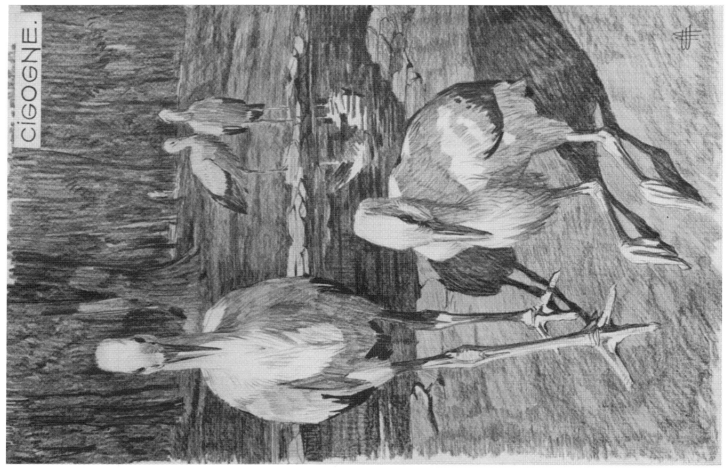

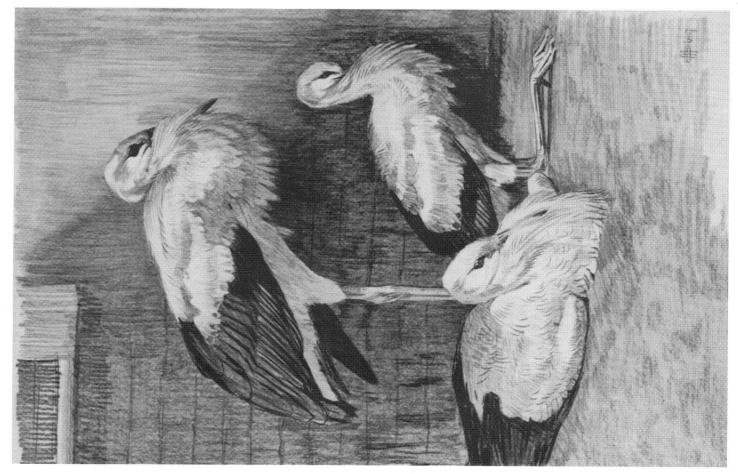

Stork

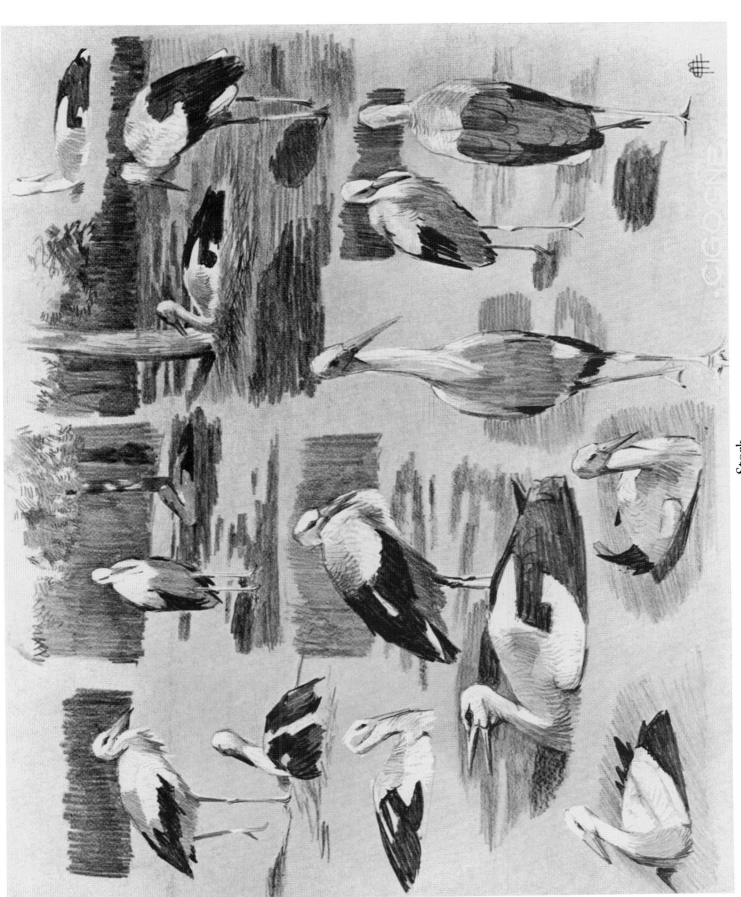

Stork

Plate 64 *Birds*

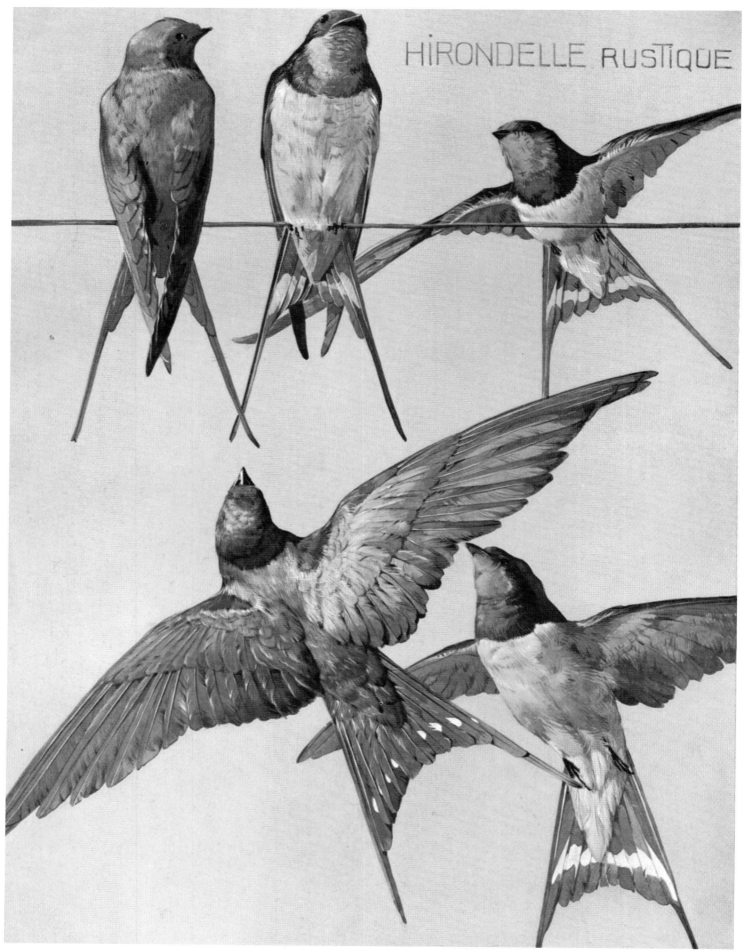

HIRONDELLE RUSTIQUE

Swallow

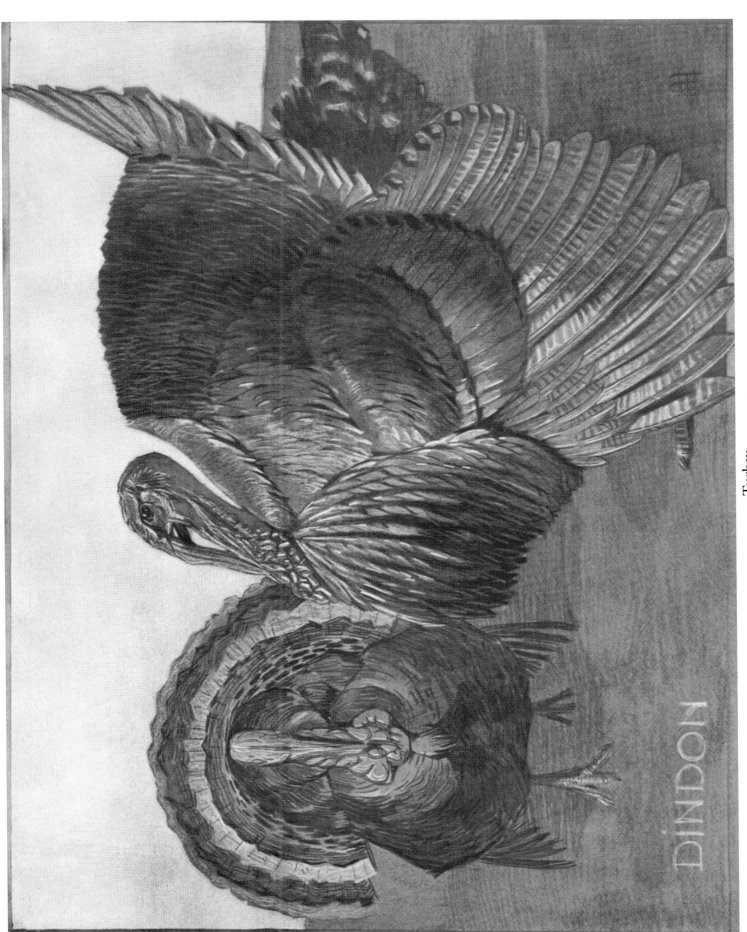

Turkey

Plate 66 *Birds*

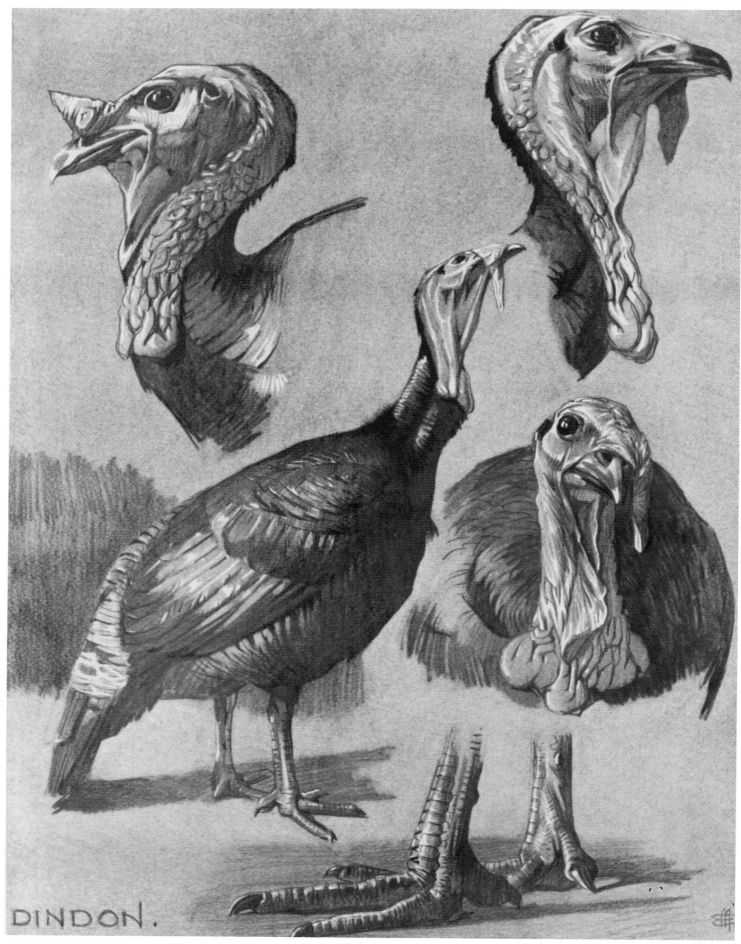

DINDON.

Turkey

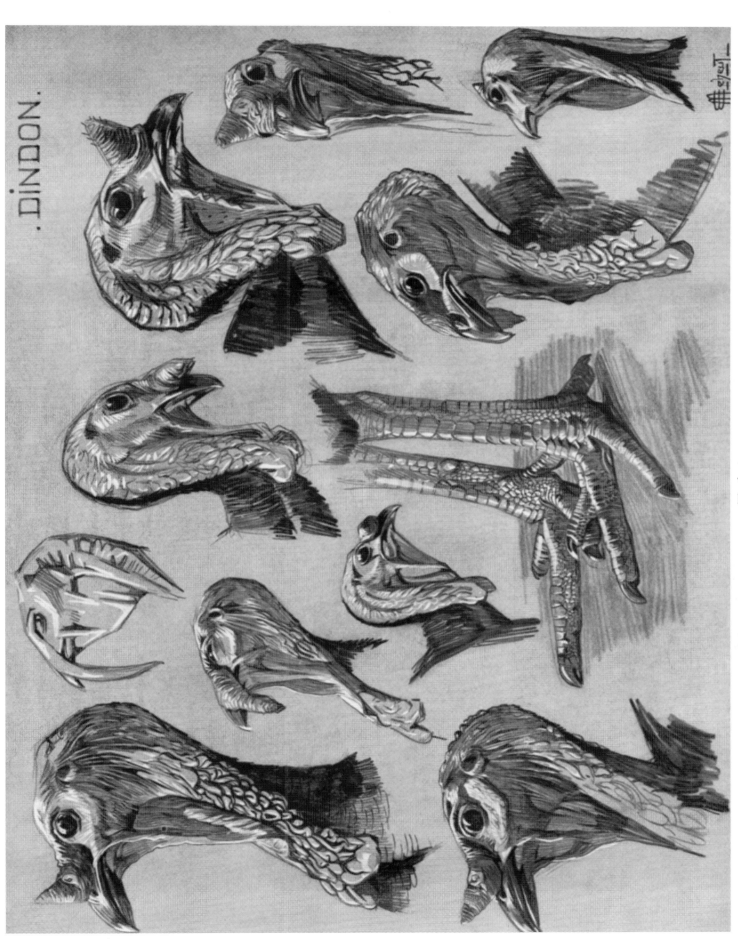

DINDON.

Turkey

Plate 68 *Reptiles*

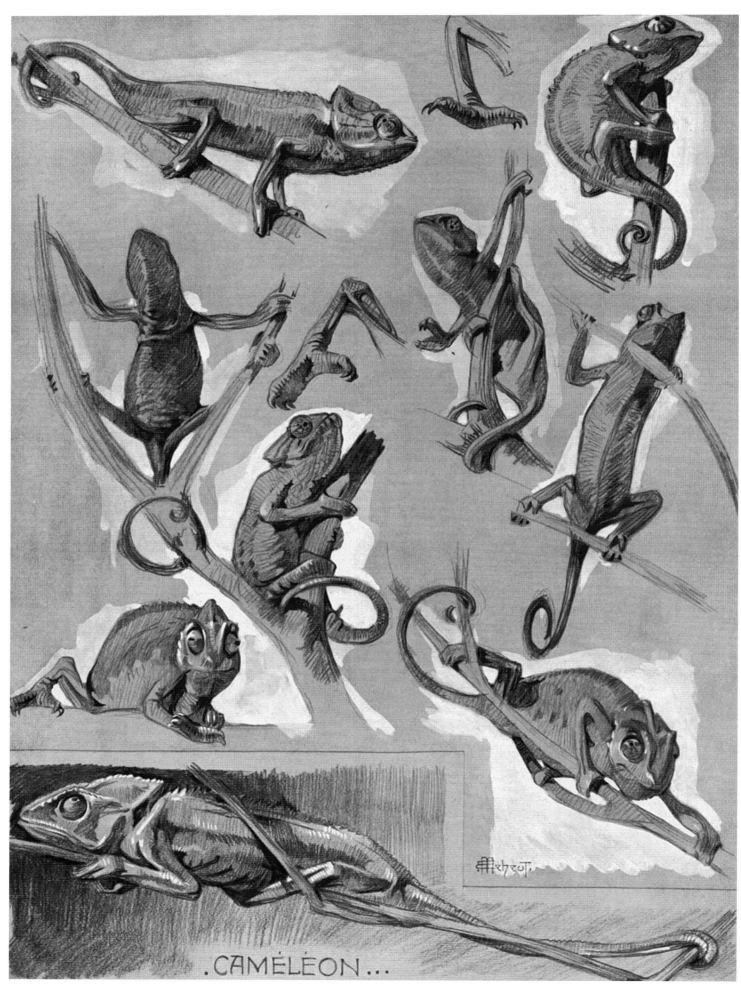

Chameleon

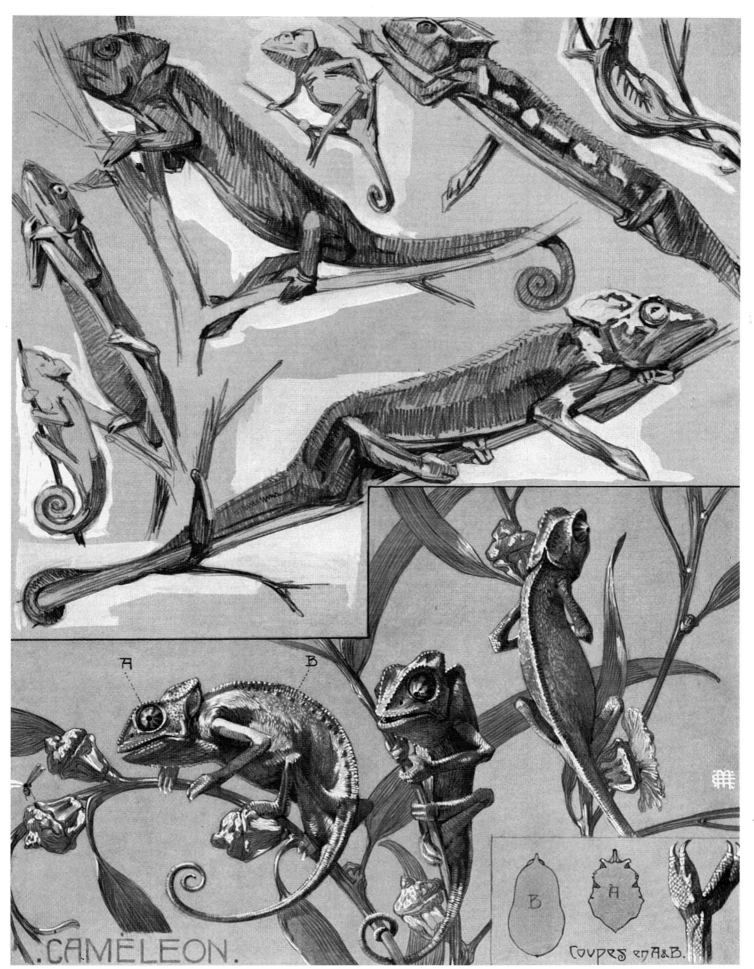

Chameleon

Plate 70 *Reptiles*

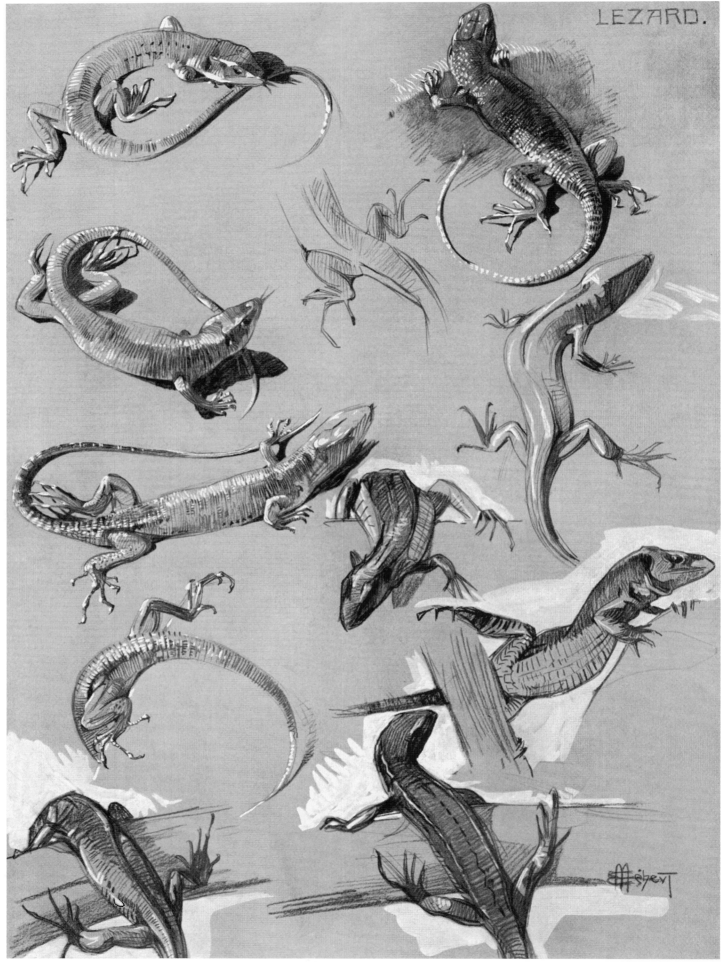

Lizard

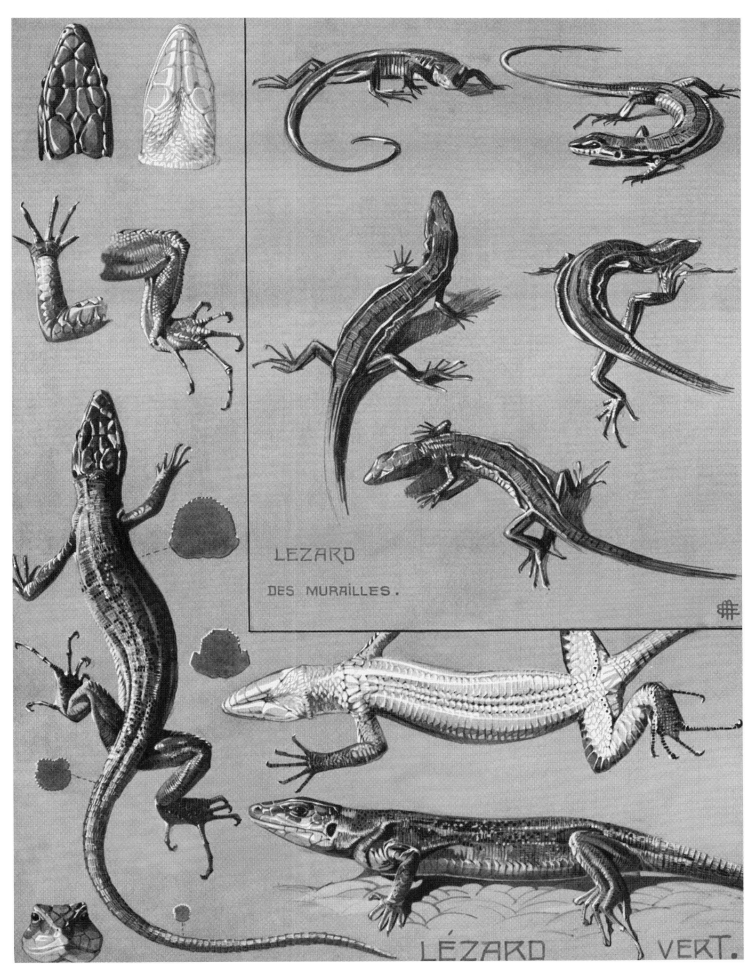

LÉZARD

DES MURAILLES.

LÉZARD VERT.

Lizard

Plate 72 *Reptiles*

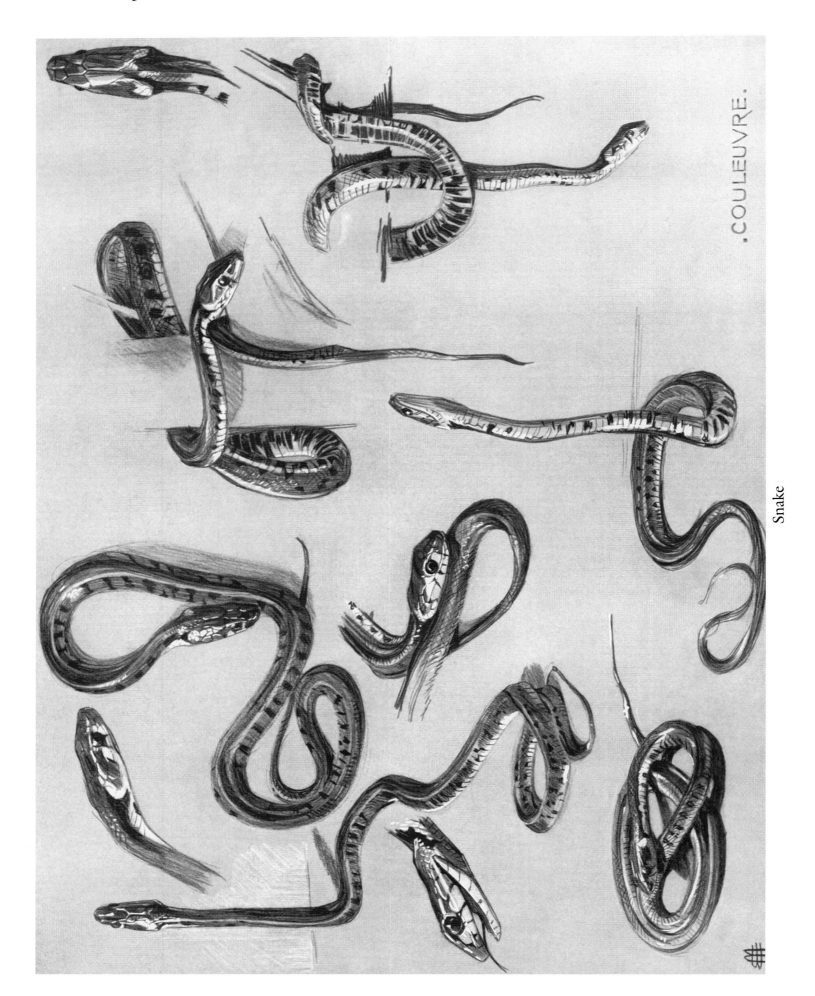

.COULEUVRE.

Snake

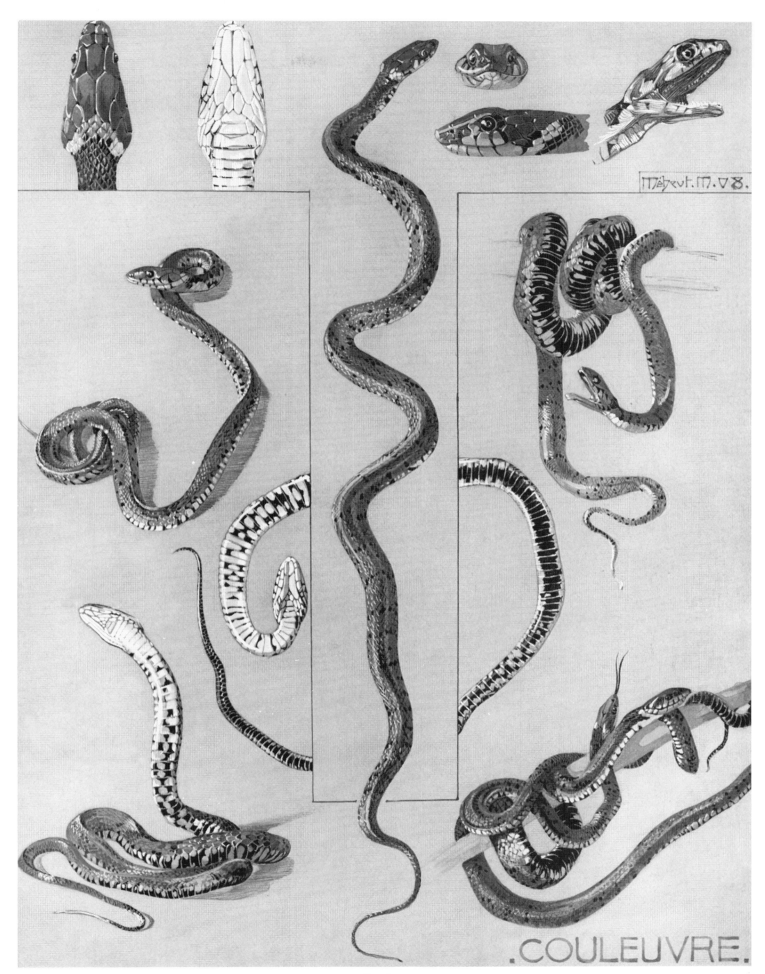

.COULEUVRE.

Snake

Plate 74 *Reptiles*

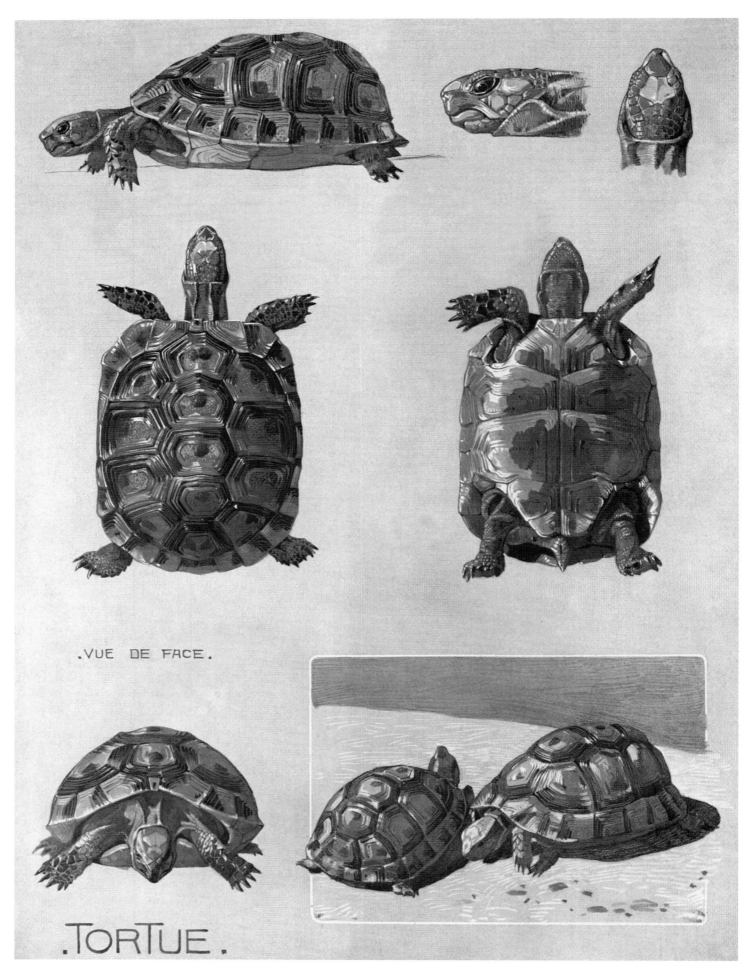

.VUE DE FACE.

.TORTUE.

Tortoise

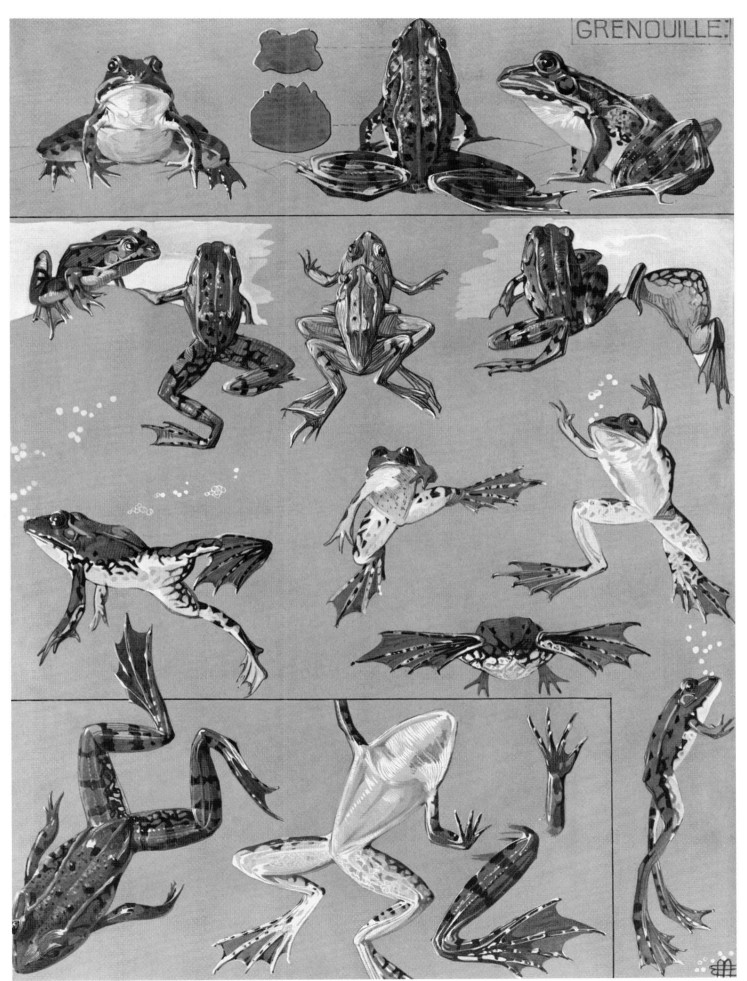

GRENOUILLE.

Frog

Plate 76 *Amphibians*

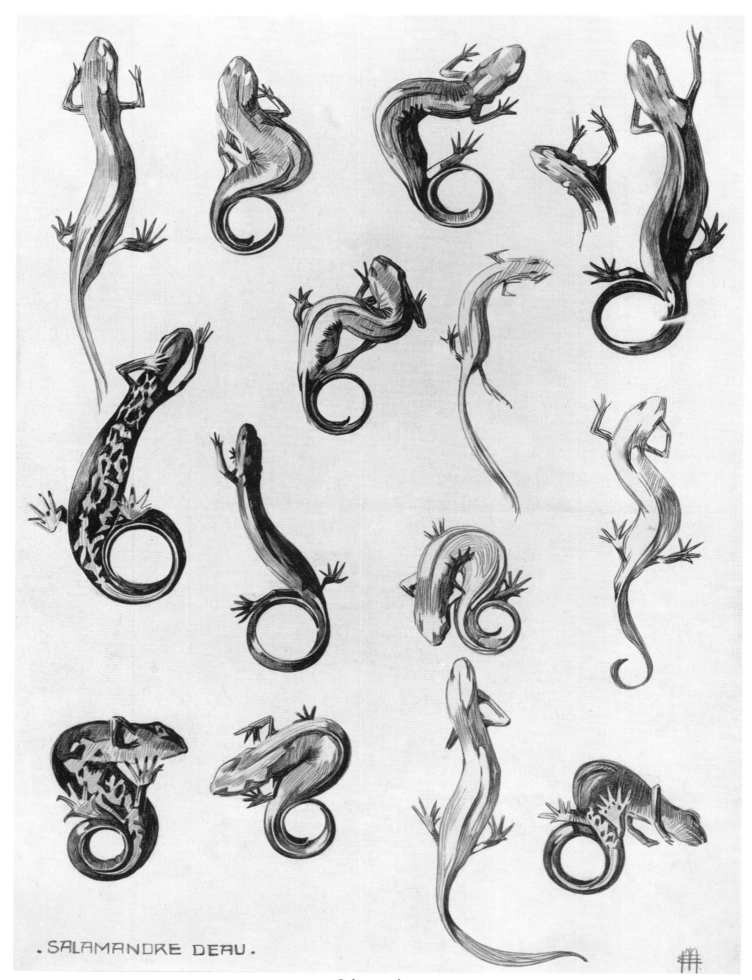

. SALAMANDRE DEAU .

Salamander

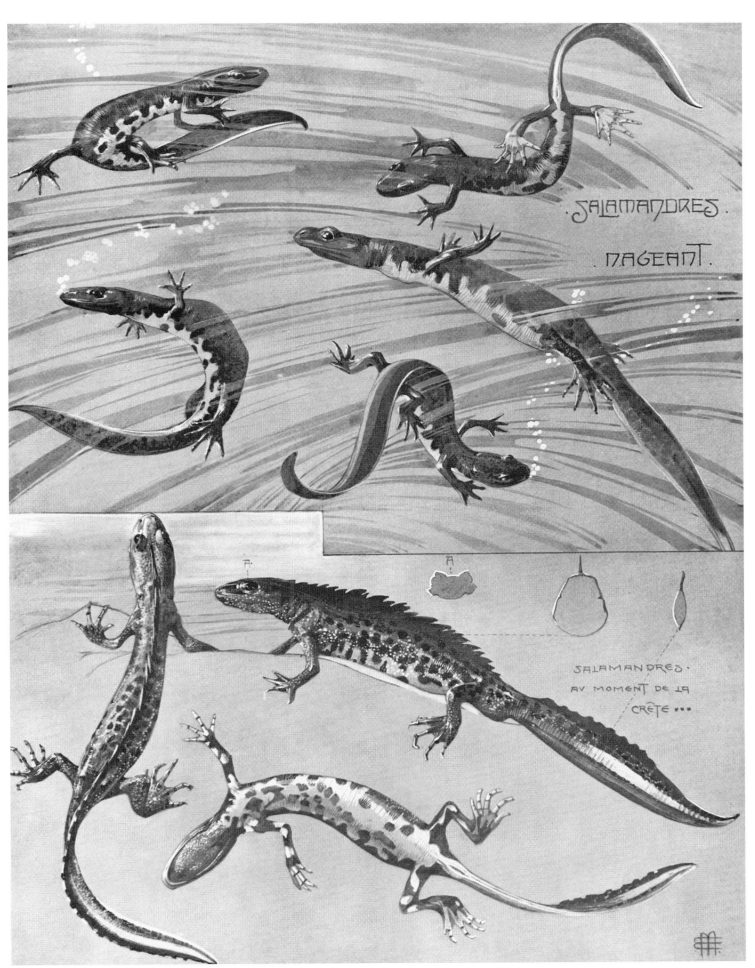

.SALAMANDRES.

.NAGEANT.

SALAMANDRES.
AV MOMENT DE LA
CRÊTE •••

Salamander

Plate 78 *Fish*

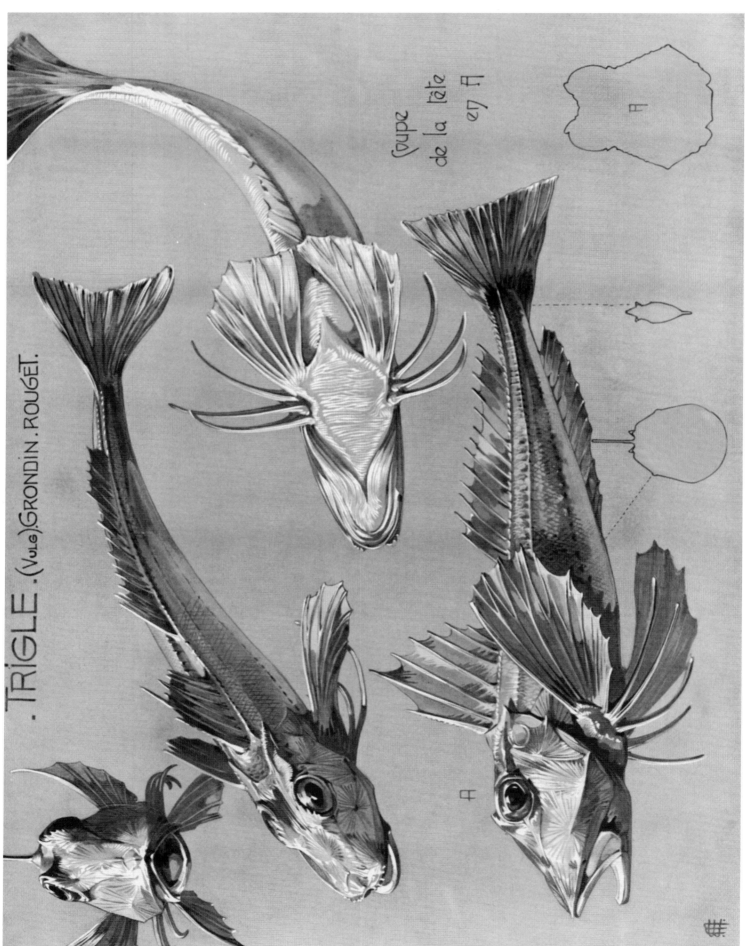

Gurnard

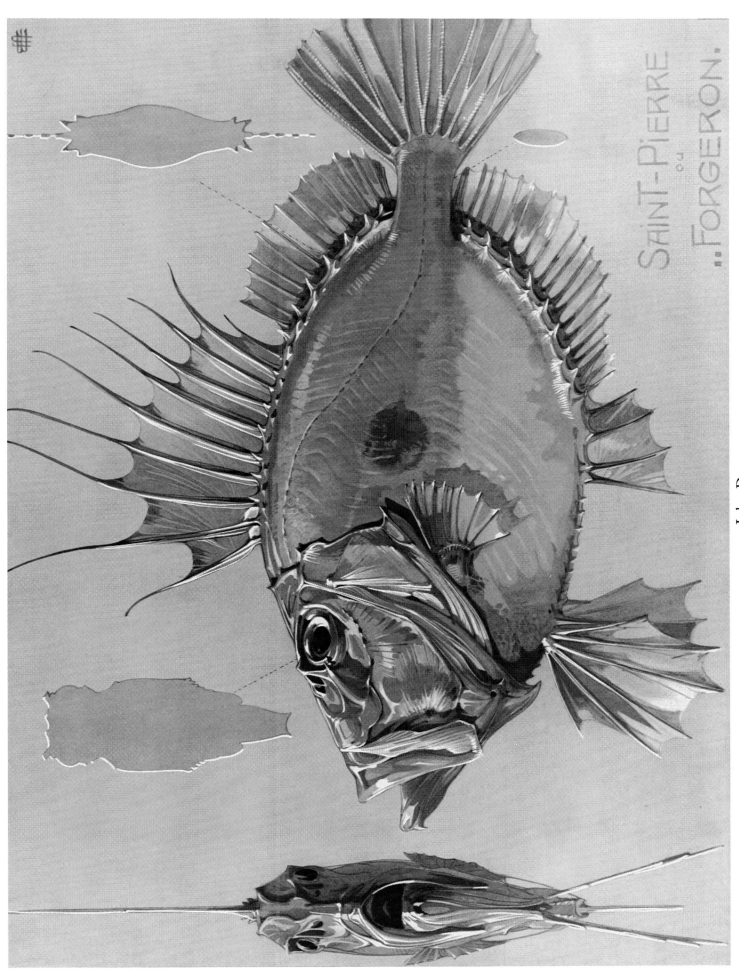

SAINT-PIERRE ou „FORGERON.“

John Dory

Plate 80 *Fish*

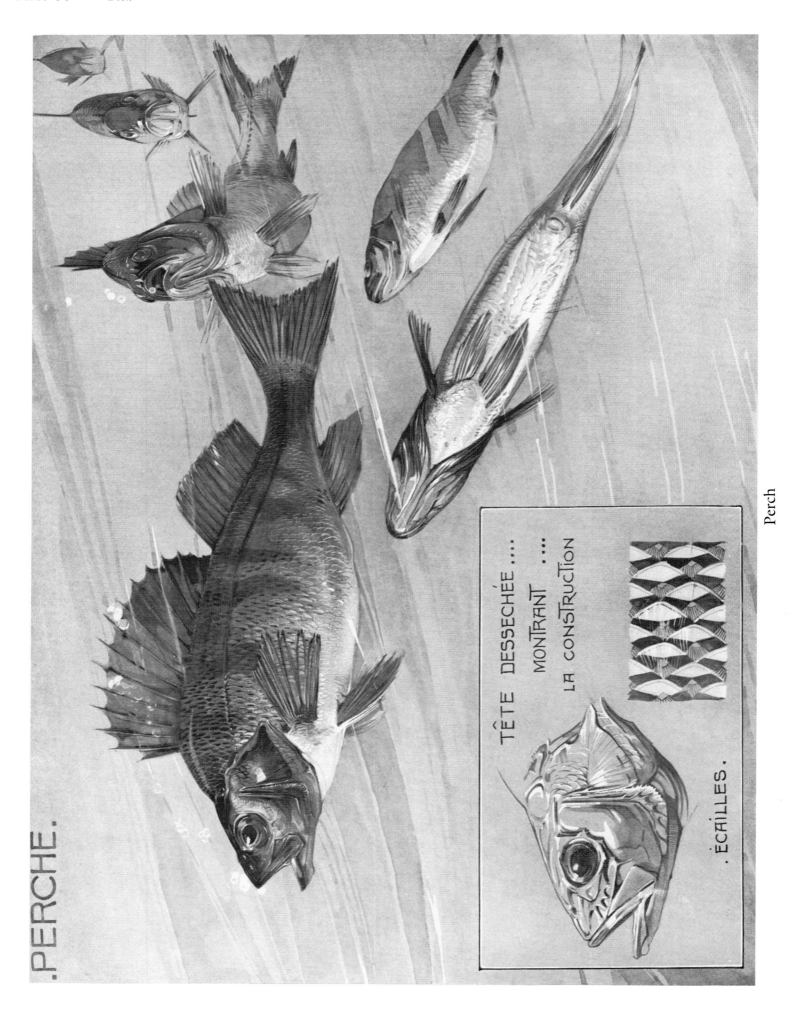

PERCHE.

TÊTE DESSÉCHÉE
..... MONTRANT
LA CONSTRUCTION

.ÉCAILLES.

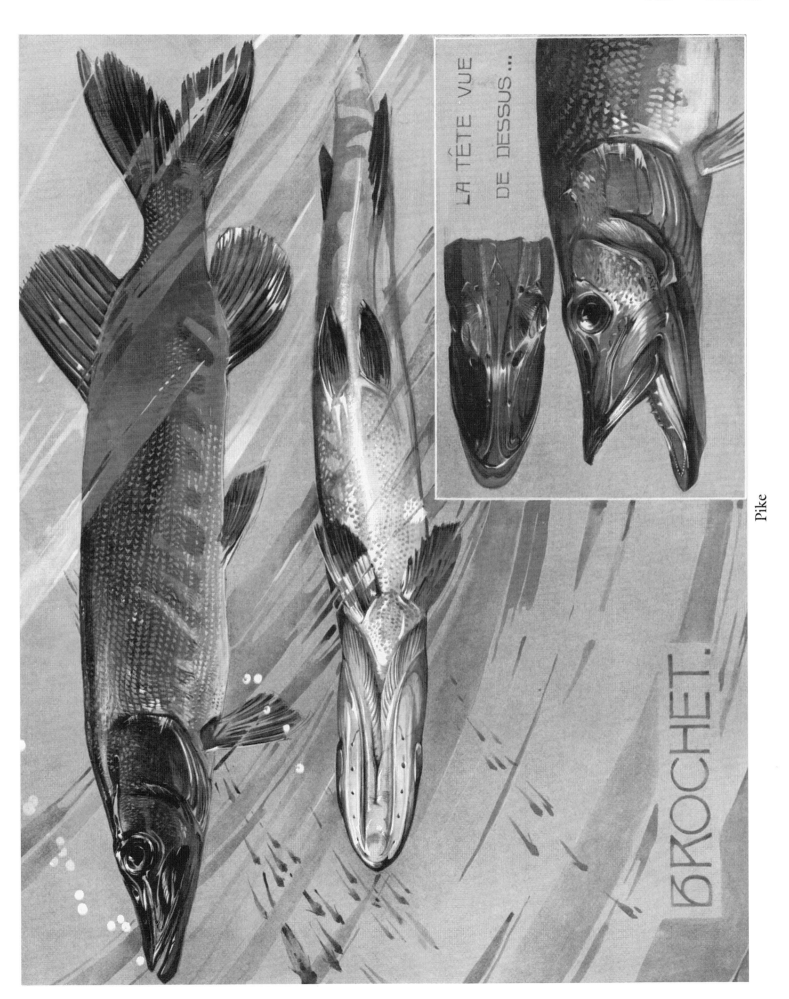

Pike

Plate 82 *Fish*

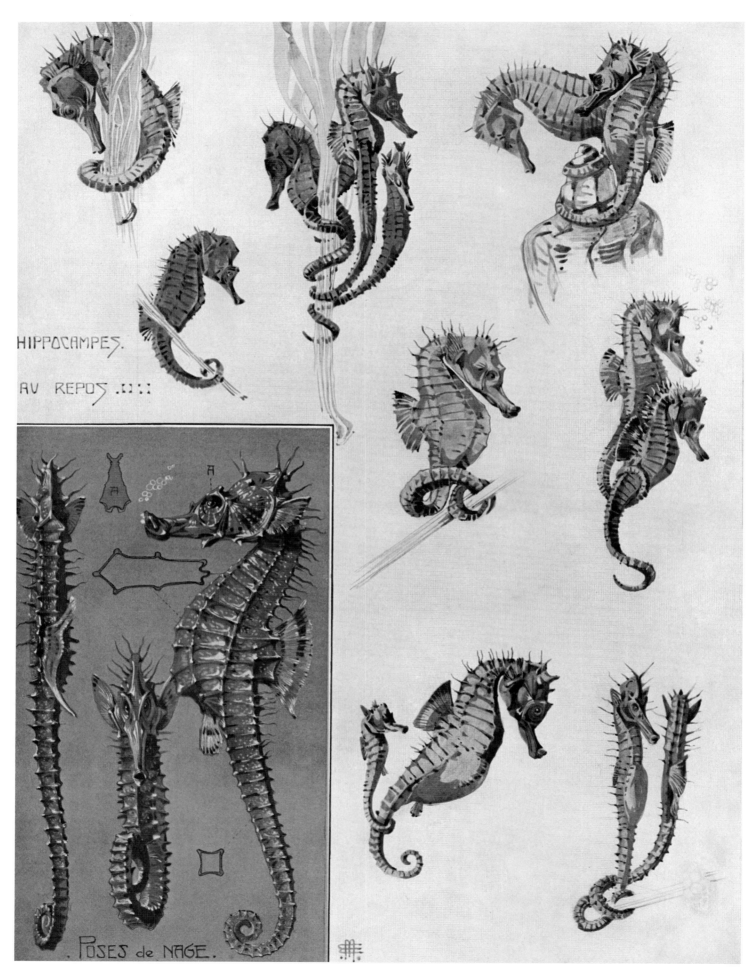

Sea horse

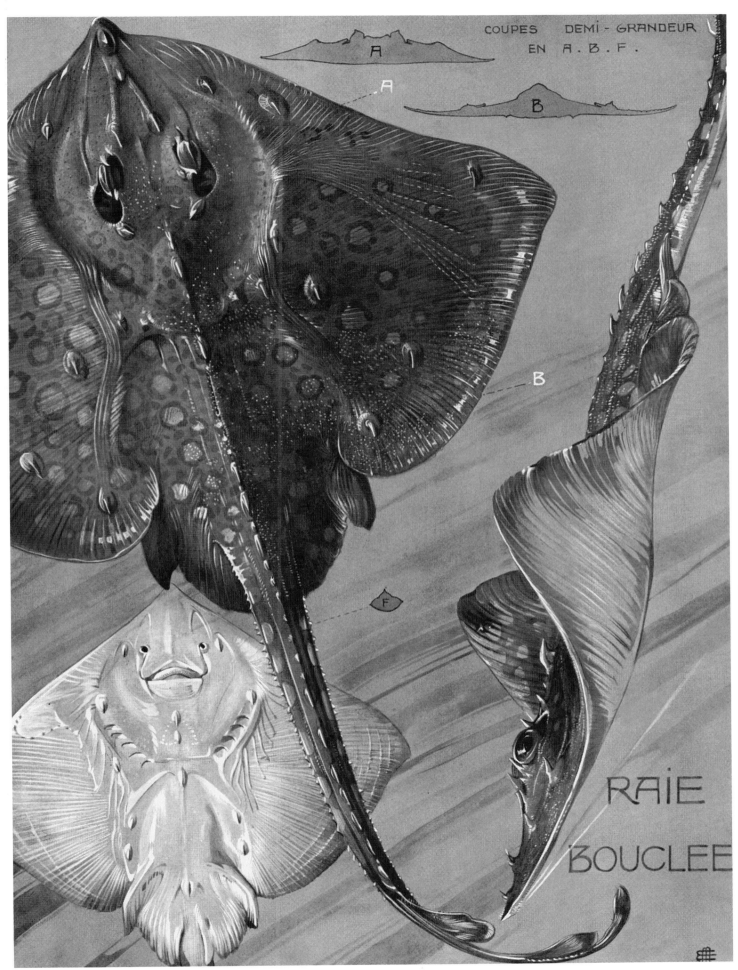

COUPES DEMI - GRANDEUR
EN A.B.F.

A

B

F

RAIE
BOUCLEE

Thornback ray (skate)

Plate 84 *Fish*

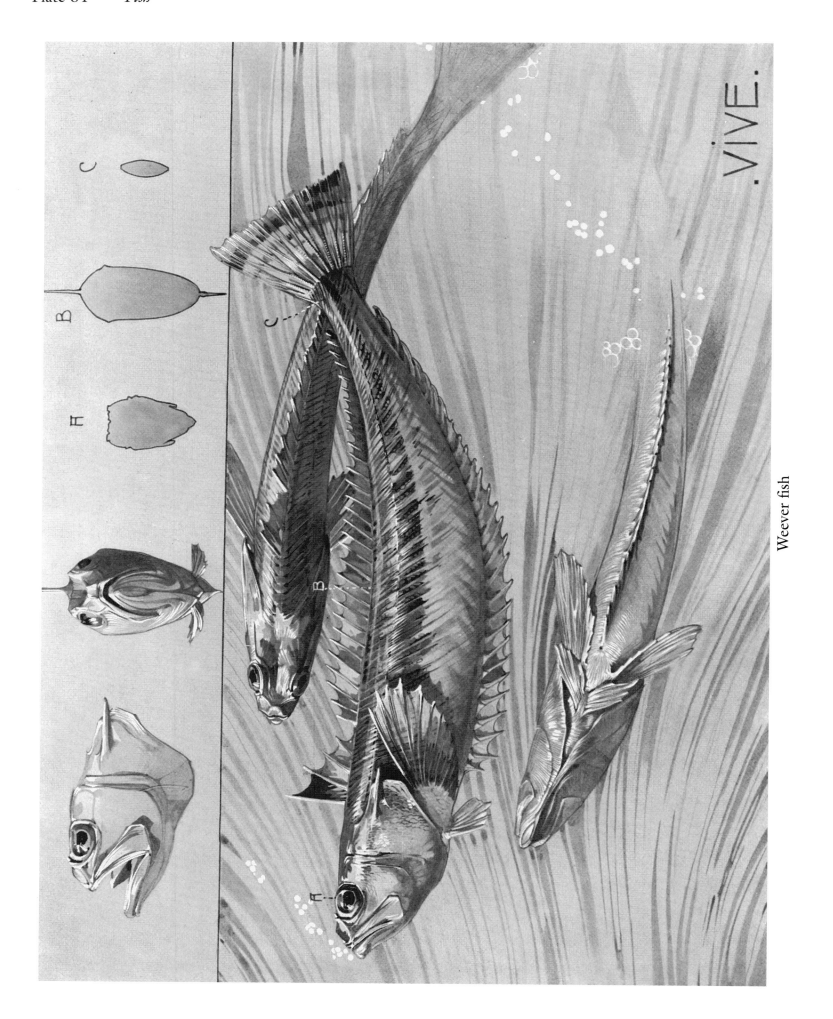

VIVE.

Weever fish

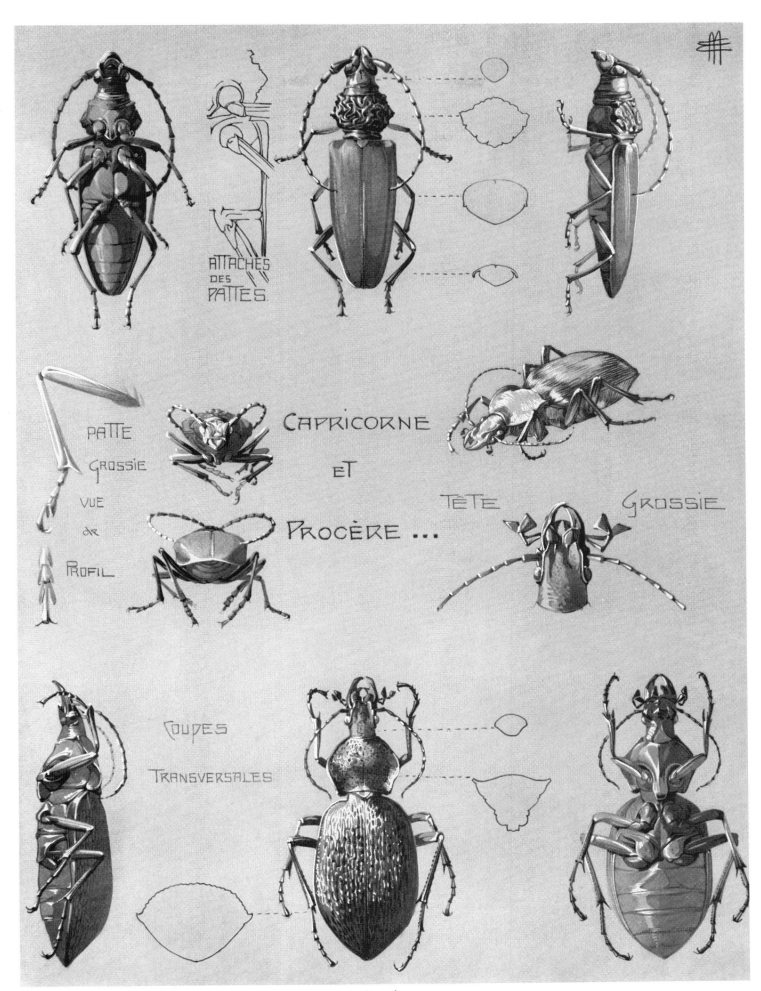

ATTACHES DES PATTES.

PATTE GROSSIE VUE DE PROFIL

CAPRICORNE

ET

PROCÈRE ...

TÊTE GROSSIE

COUPES TRANSVERSALES

Beetle

Plate 86 *Insects*

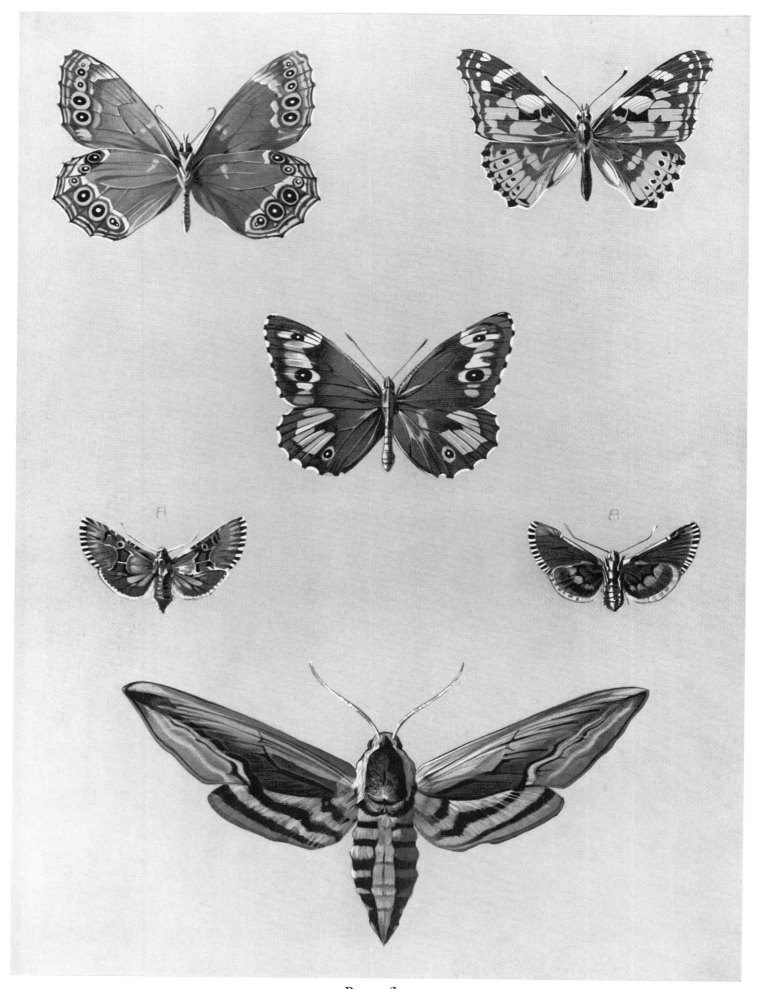

Butterfly

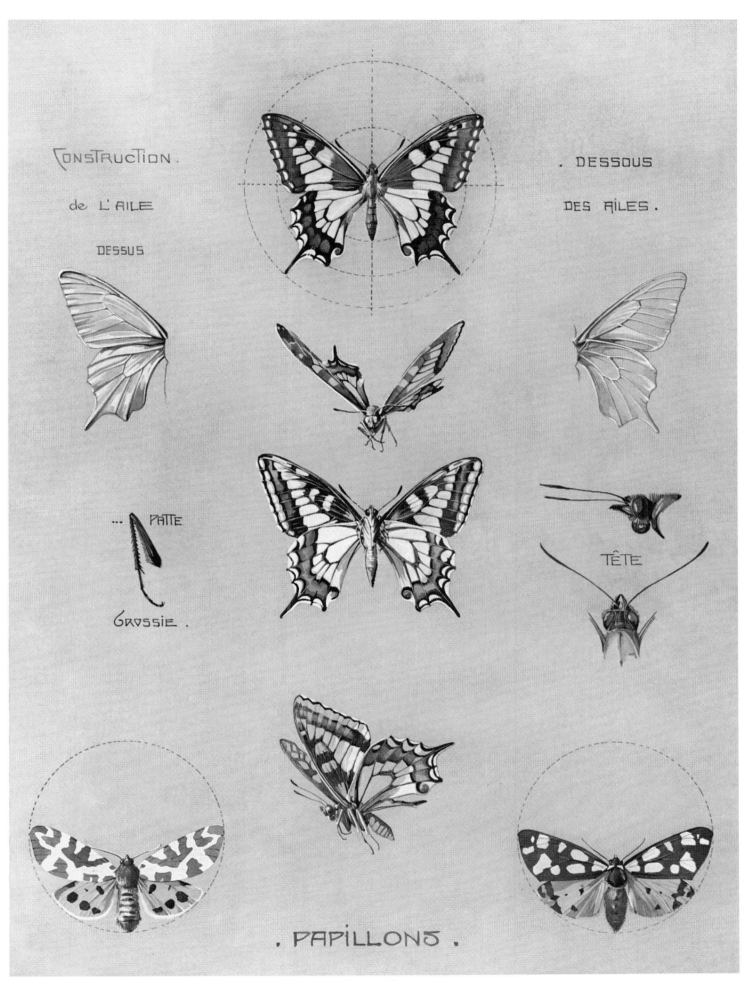

CONSTRUCTION.

de L'AILE

DESSUS

. DESSOUS

DES AILES.

... PATTE

GROSSIE .

TÊTE

. PAPILLONS .

Butterfly

Plate 88 *Insects*

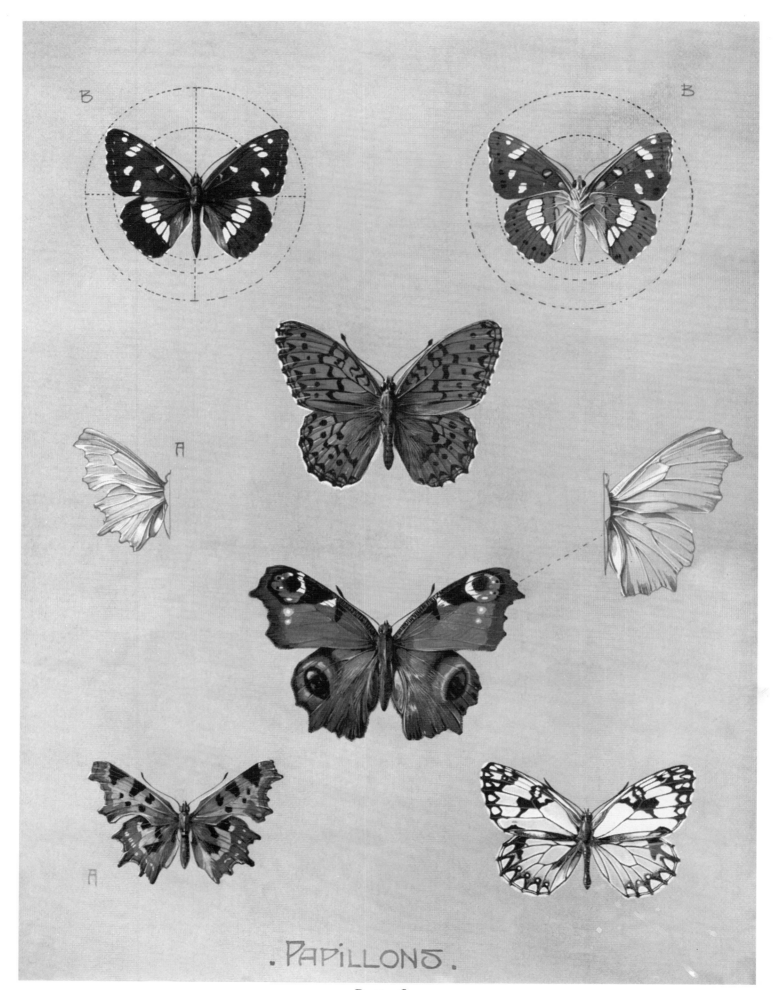

. PAPILLONS .

Butterfly

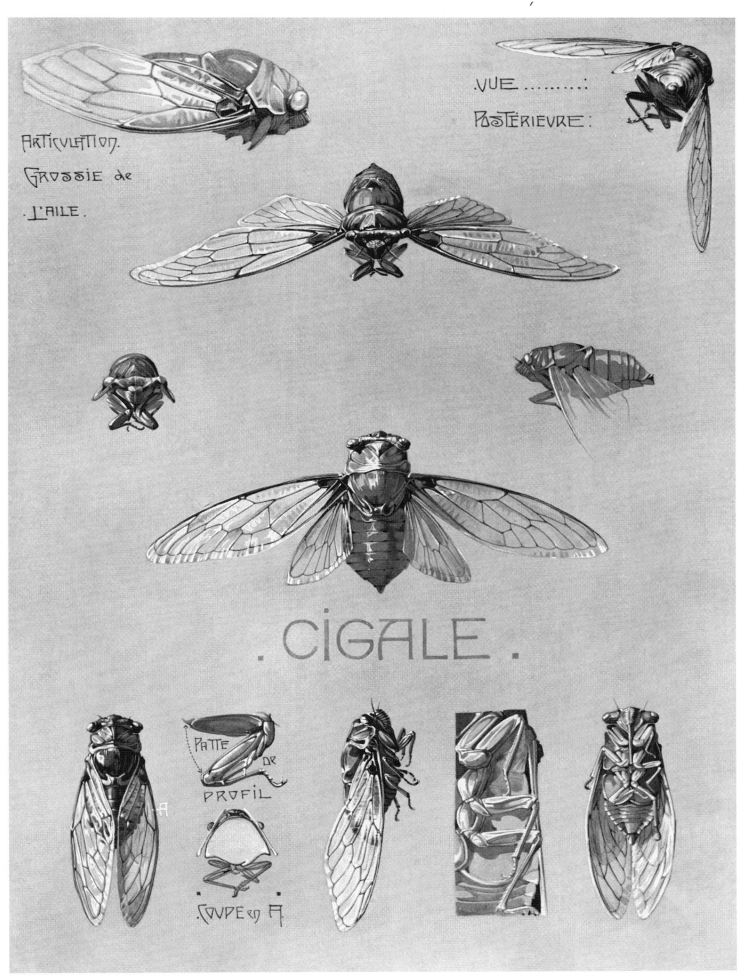

Cicada

Plate 90 *Insects*

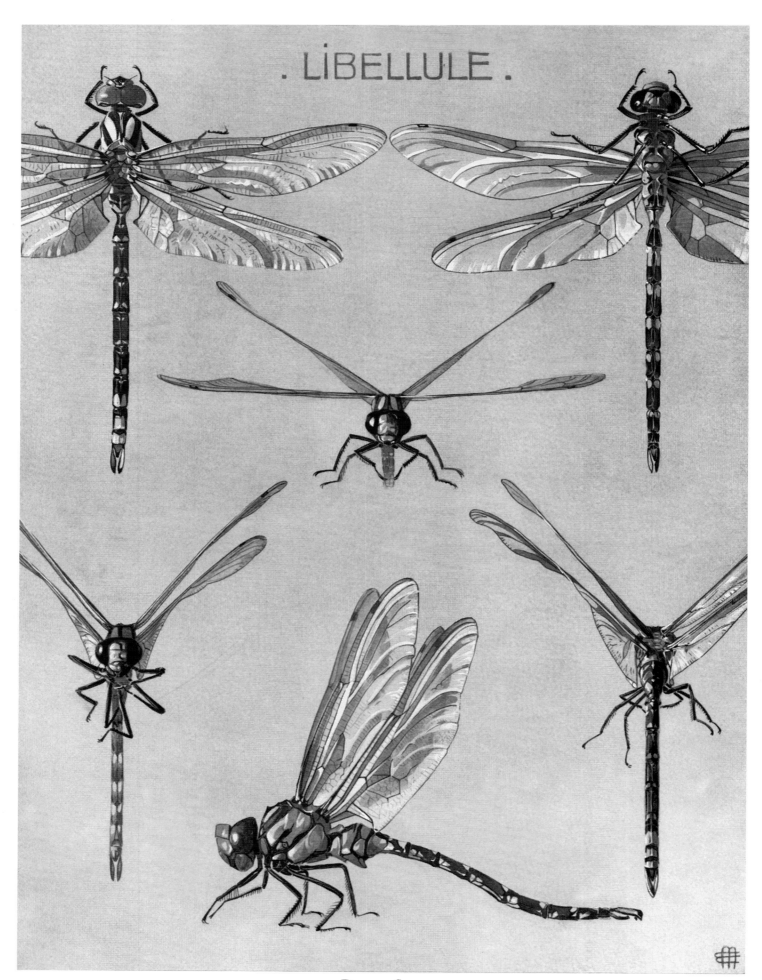

. LIBELLULE .

Dragonfly

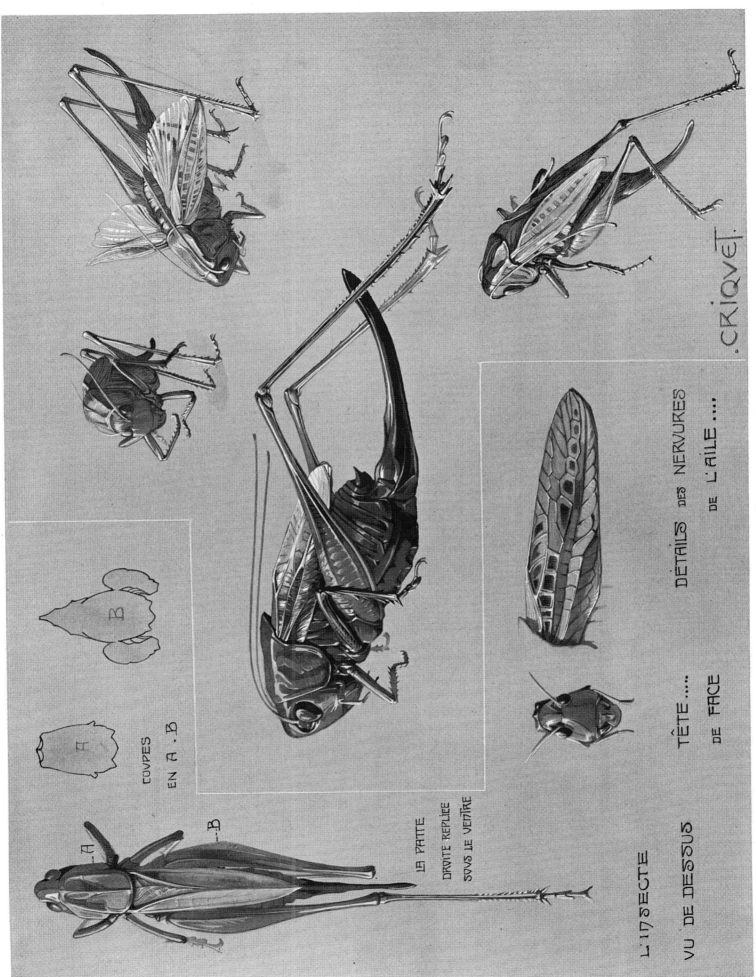

Locust

Plate 92 *Insects*

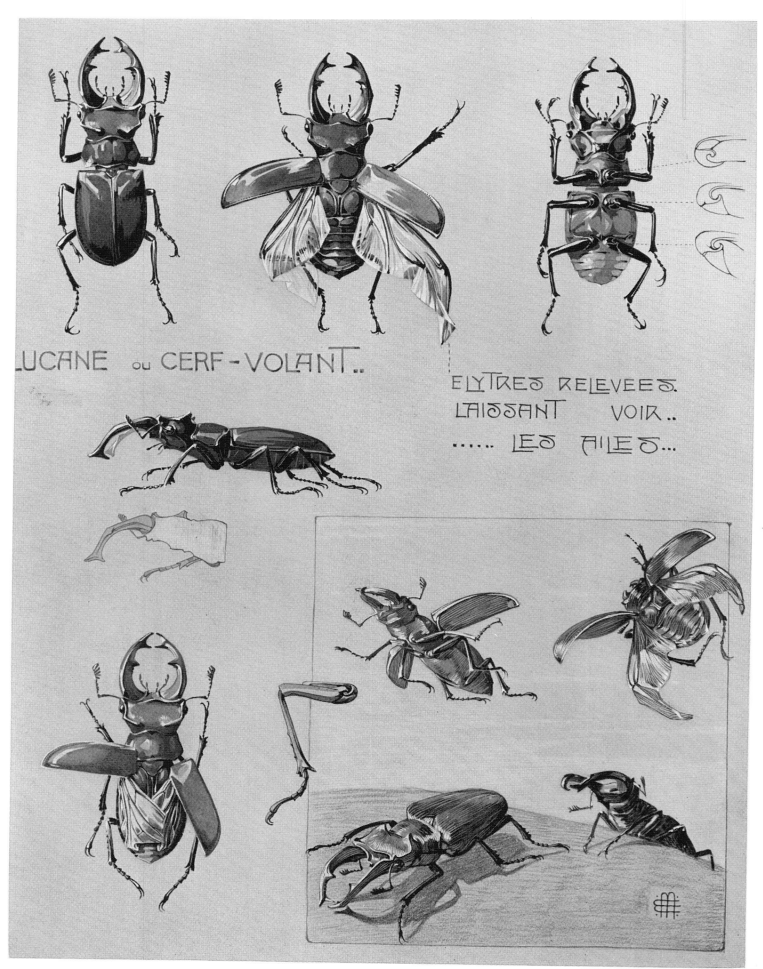

LUCANE ou CERF-VOLANT..

ELYTRES RELEVEES.
LAISSANT VOIR..
...... LES AILES...

Stag beetle

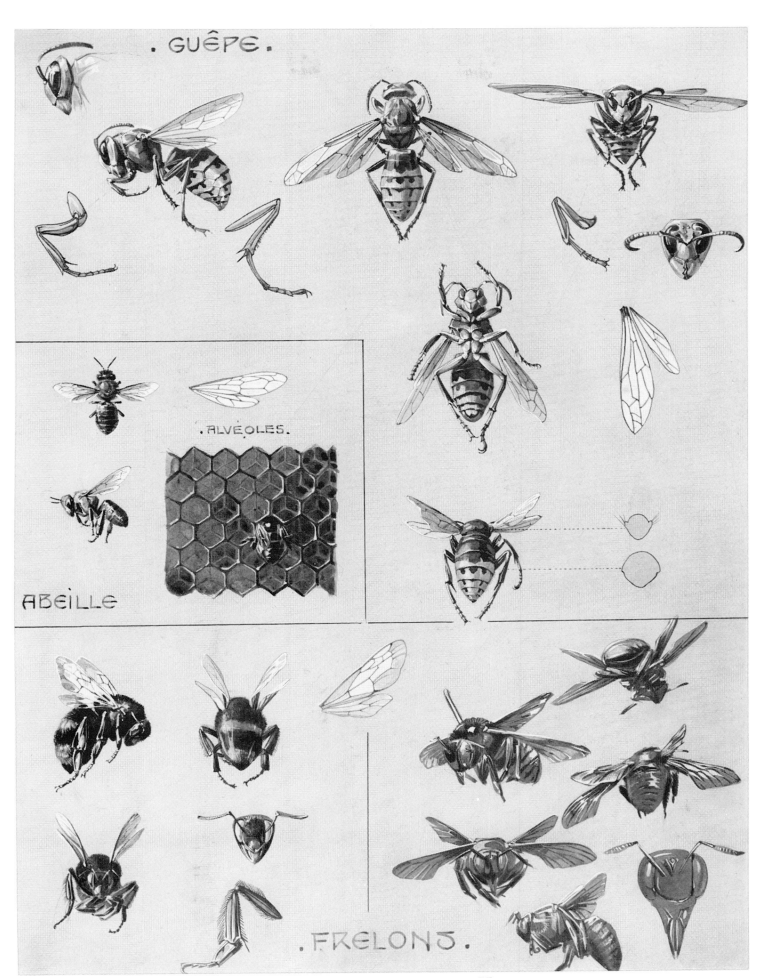

. GUÊPE .

. ALVÉOLES .

ABEILLE

. FRELONS .

TOP: Wasp. MIDDLE: Bee. BOTTOM: Hornet.

Plate 94 *Arachnid*

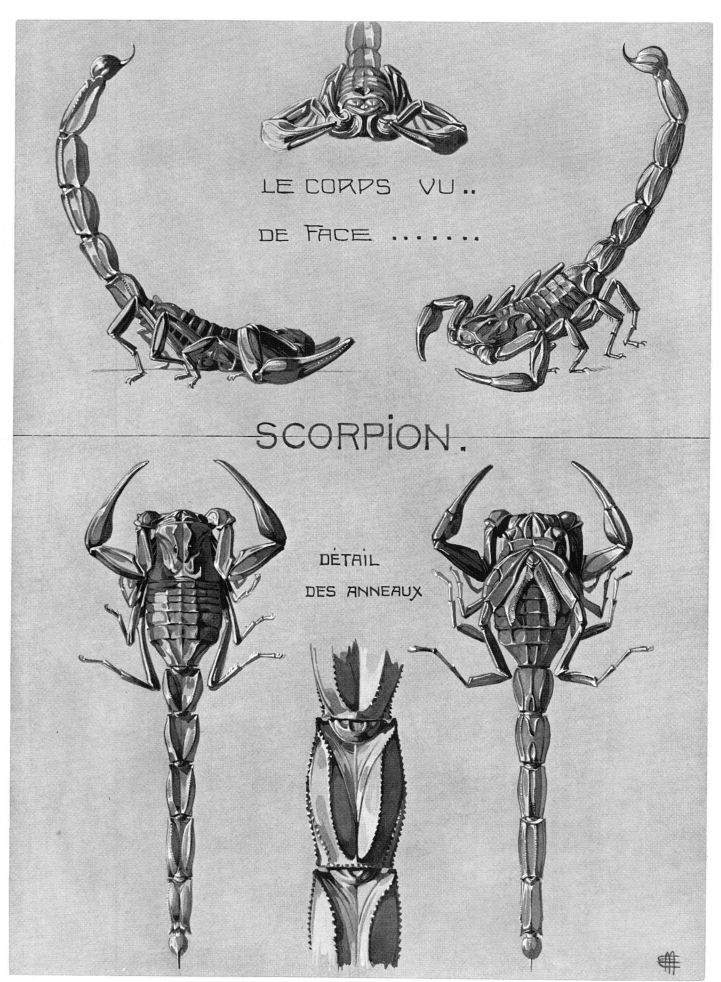

LE CORPS VU..

DE FACE

SCORPiON.

DÉTAIL

DES ANNEAUX

Scorpion

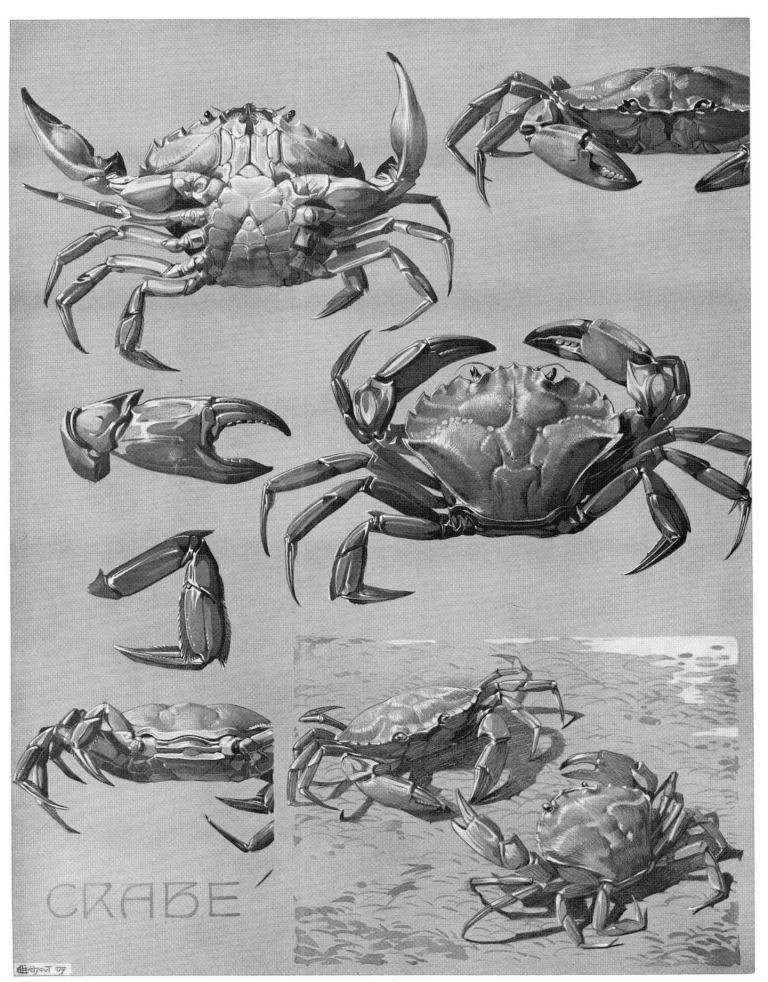

Crab

Plate 96 *Crustaceans*

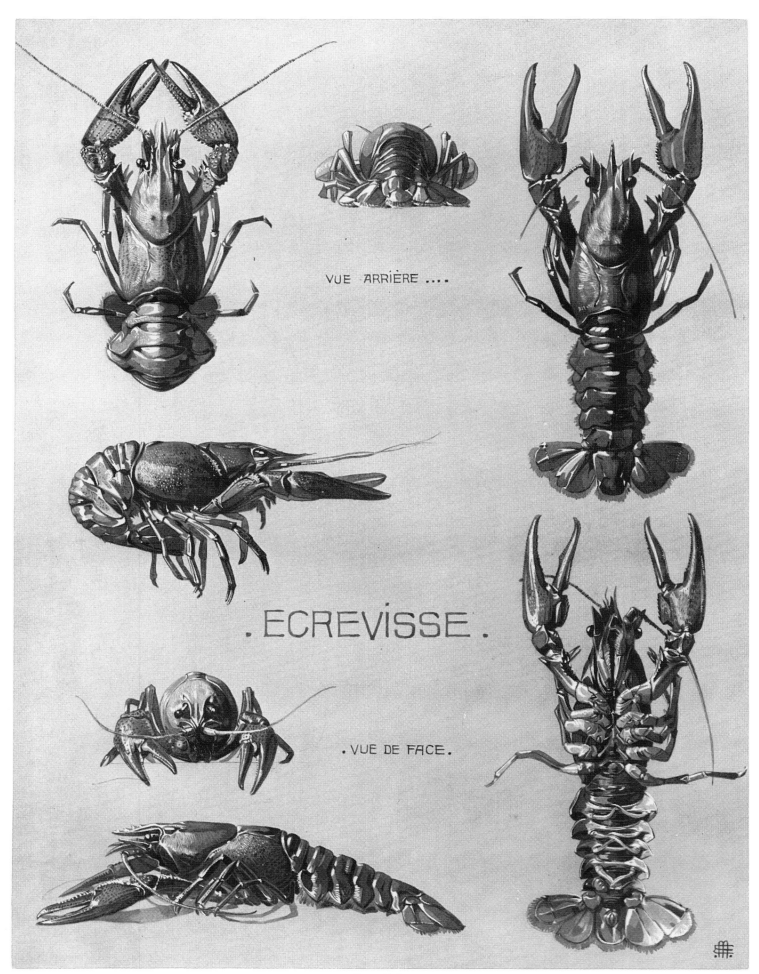

VUE ARRIÈRE

. ECREVISSE .

. VUE DE FACE .

Crayfish

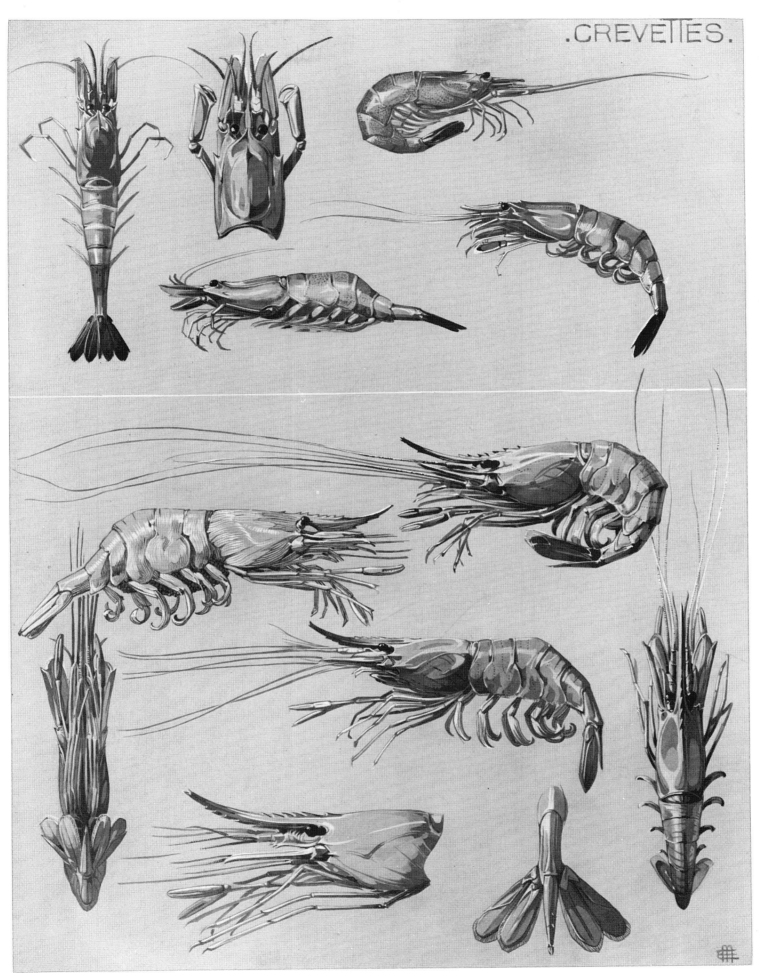

.CREVETTES.

Shrimp

Plate 98 *Mollusks and Zoophytes*

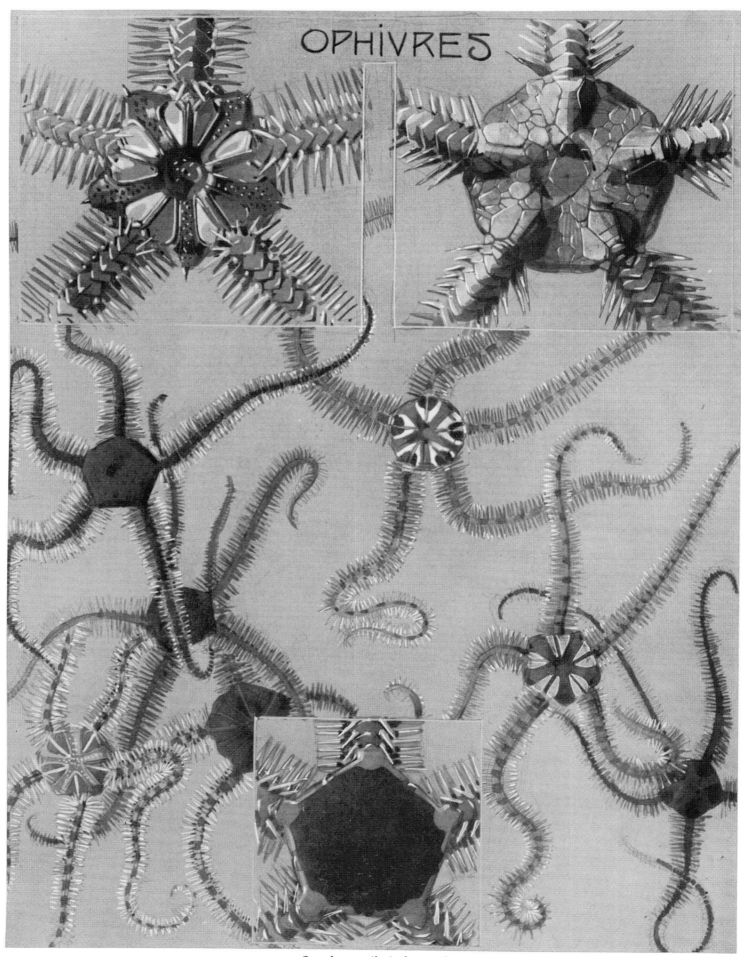

Sand star (brittle star)

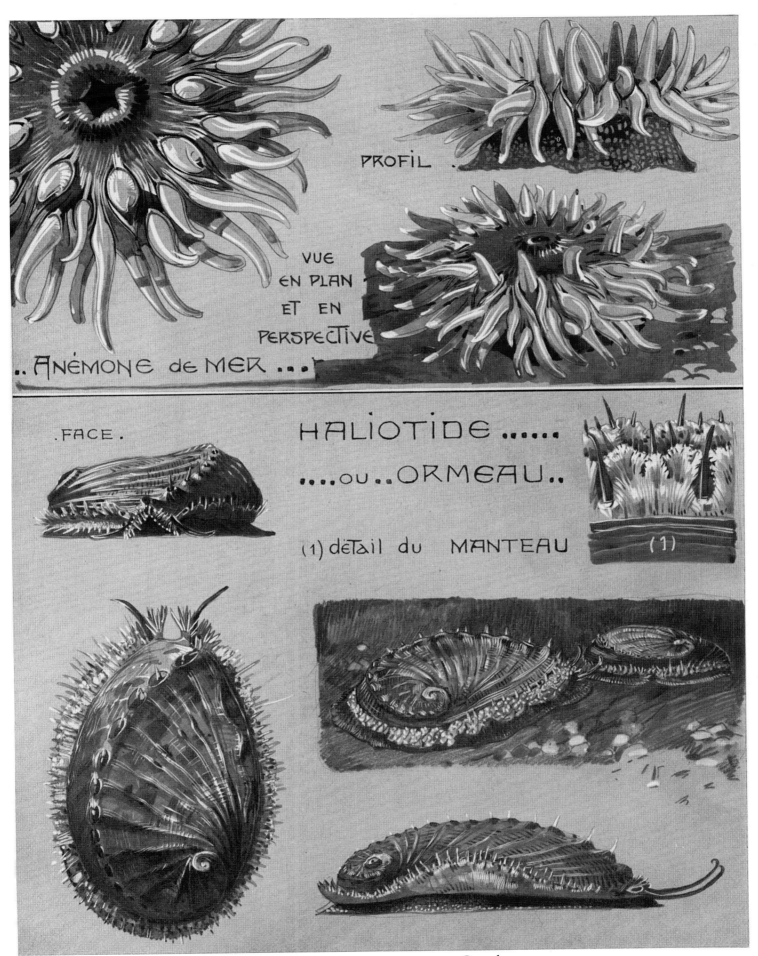

PROFIL

VUE
EN PLAN
ET EN
PERSPECTIVE
.. ANÉMONE de MER ...

.FACE.

HALIOTIDE
....ou .. ORMEAU..

(1) déTail du MANTEAU (1)

TOP: Sea anemone. BOTTOM: Conch.

Plate 100 *Mollusks and Zoophytes*

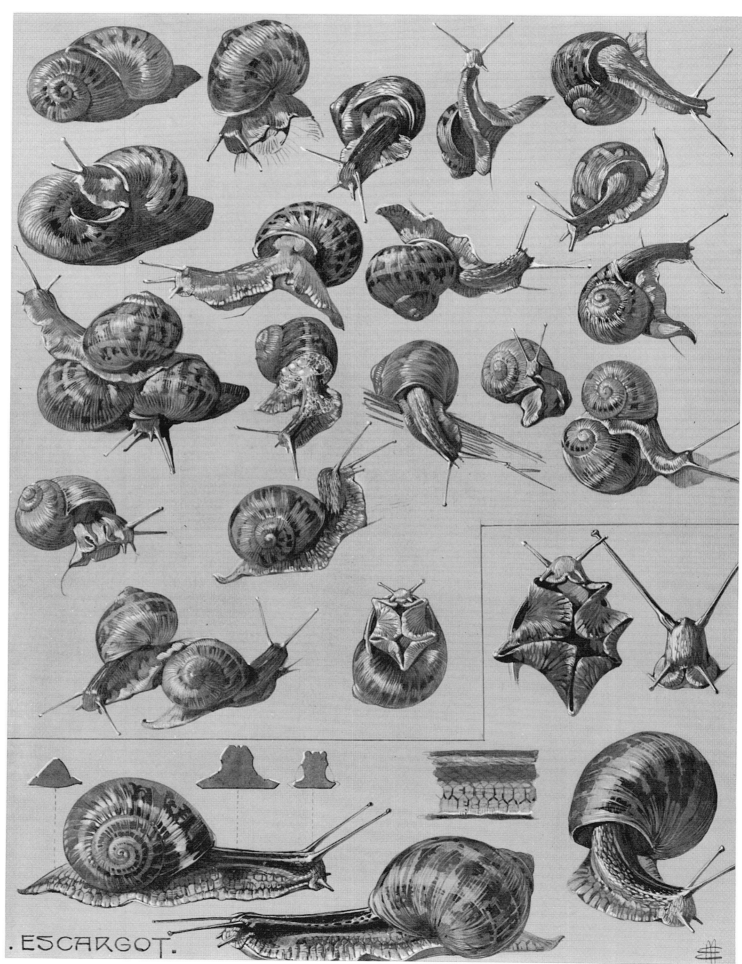

. ESCARGOT .

Snail

INDEX

References are to plate numbers.